How To Paint With **PASTELS** JOHN BLC

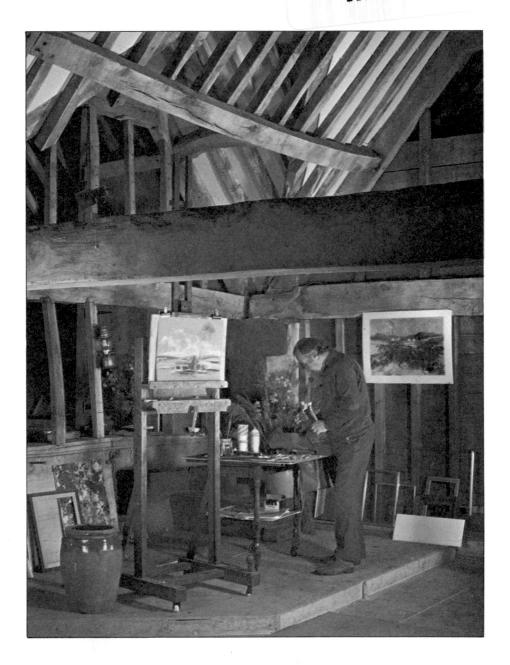

HPBooks

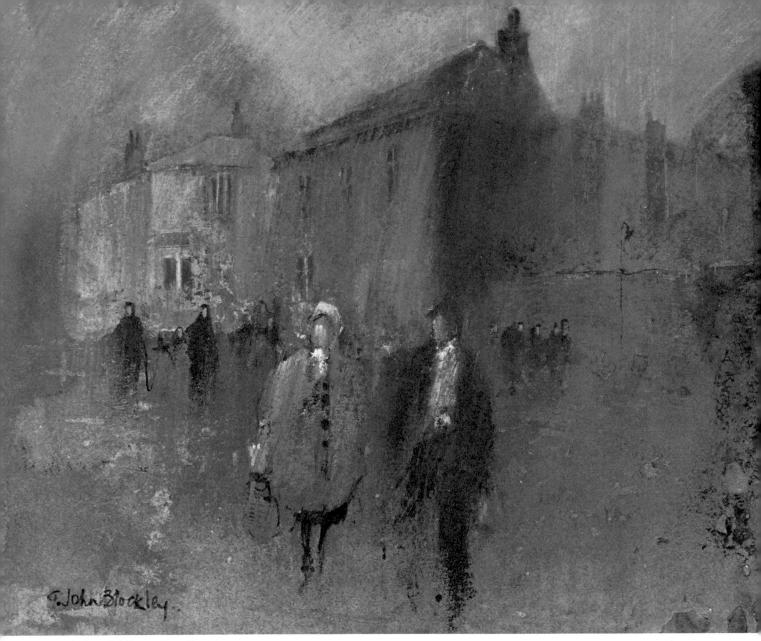

Industrial Town, Late Evening

Industrial towns often provide unusual conditions to paint. Here, the sky appears orange because of the evening light filtering throus industrial haze.

Published in the United States by HPBooks P.O. Box 5367 Tucson, AZ 85703 602/888-2150

Publishers: Bill and Helen Fisher Executive Editor: Rick Bailey Editorial Director: Randy Summerlin Art Director: Don Burton

©1980 John Blockley ©1982 Fisher Publishing, Inc. Printed in U.S.A.

First Published 1980 by Collins Publishers, Glasgow and London

ISBN 0-89586-159-3 Library of Congress Catalog Card Number: 81-85410 Notice: The information in this book is true and complete to the best of our knowledge. All recommendations are made without guarantees on the part of the author or HPBooks. The author and HPBooks disclaim all liability incurred in connection with the use of this information.

CONTENTS

Portrait Of An Artist— John Blockley
Understanding Pastels 6
Equipment
Paper
How To Apply Pastel 16
Sketching 20
Painting Figures
Moorland Cottages 24
Cottage Details
Cottage Interior
Anglesey Cottages 30
Staithes, Yorkshire
Low Water 34
Hill Farmer
Portrait
Northumberland House 42
Oil Lamp 46
Apples 50
Roadside Trees 54
Trees
Cotswold Landscape 60
Fixing Pastels
Index

Portrait Of An Artist – John Blockley

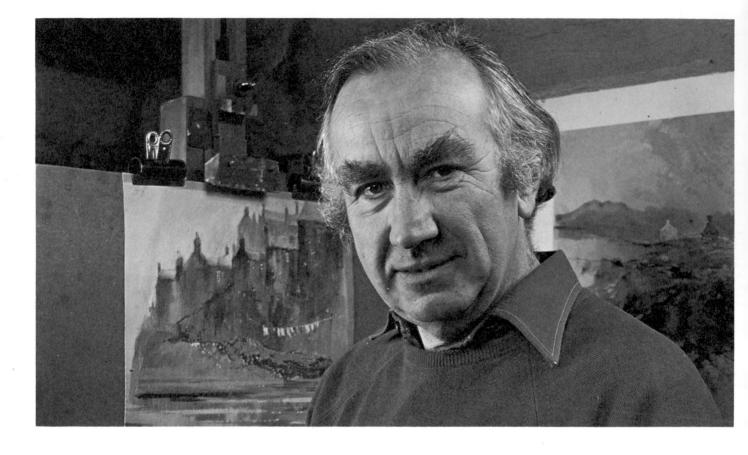

John Blockley was born in Knighton, Shropshire, England.

He now lives in Lower Swell, a small village in the Cotswolds, where he teaches courses for British and foreign students. He converted a large stone barn dating back to the 16th century into a teaching center and studio.

Blockley views painting as a continuing exploration. He is always looking for new ideas and interpretations. His work is based on constant observation of everything around him. He is not interested in photographic likenesses of subjects, distortions or contrived effects. He prefers to seek the special moods or qualities of a subject, such as light, surface textures and patterns. Blockley's interests have evolved through many years of painting landscapes throughout Britain. He paints mountains, moors and industrial subjects. He paints large landscapes and small, intimate studies of corner shops and shoppers. He deliberately moved to the Cotswolds to work in a new environment. He now paints Cotswold buildings, woodlands and rolling landscapes.

Blockley paints mostly in pastels and watercolors. He is a member of the Royal Institute of Painters in Watercolor and the Pastel Society of Great Britain. He has served on the council of both societies for several years and participates in their annual exhibits at the Mall Gallery in London. His paintings are in collections all over the world.

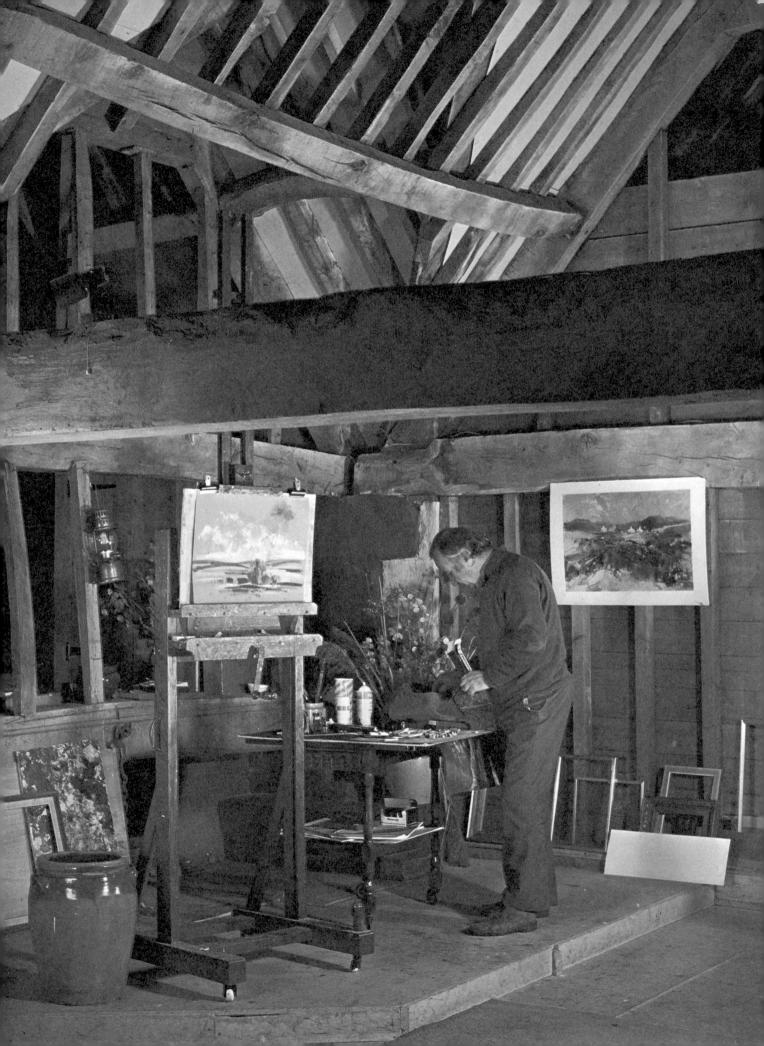

Understanding Pastels

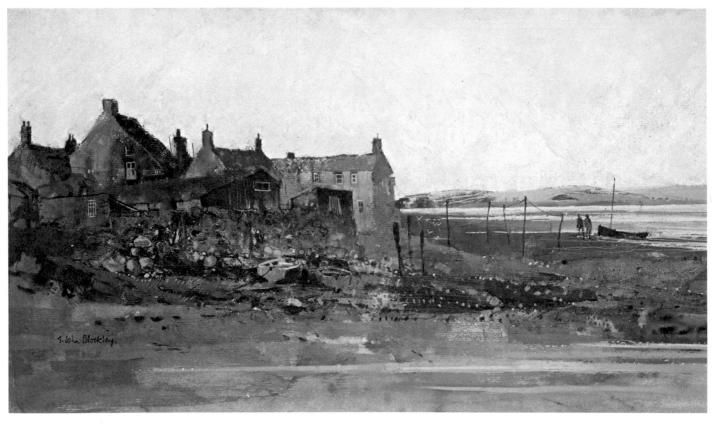

Ravenglass, Cumbria

Pastel painting can be as colorful and vigorous as any method of painting. It is a dry medium. Its powdery surface increases the refraction of light, so pastel paintings have an intensity of color unchallenged by many other media. Because it is dry, there are no frustrations of waiting for paint or paper to dry. Pastel color is applied directly to the painting surface. It can outlast oil paint because it has no oil or varnish to yellow and crack with age.

Many people who are attracted to the paintings of ballet dancers by Edgar Degas, don't realize that some were made with pastels. Degas exploited the special properties of pastels. He produced exciting paintings that seem to vibrate with color. His *Dancers in Blue* was painted in 1890 and is typical of his technique with pastels. It shows a group of dancers dressed in blue, set against a rich tapestrylike background of brilliant splashes of orange and red. Degas applied color in layers with short, quick strokes—dashes and dots of pastel so the colors underneath show through. He painted racehorses, rippling grass and reflected light. Movement of color and light is apparent in all his paintings of figures, interiors, landscapes, beach scenes and skies. More than anyone, Degas demonstrates the possibilities of the pastel medium.

Pastel painting in its present form began in the 18th century, although chalk drawings were made on cave walls in prehistoric times. Pastel paintings more than 200 years old are as bright and fresh today as when they were painted. Pastels require no more protective treatment than that given to other types of painting. The best way to protect a pastel is to frame it under glass, with a surrounding mat between the pastel surface and the glass. This method prevents the glass from rubbing against the picture.

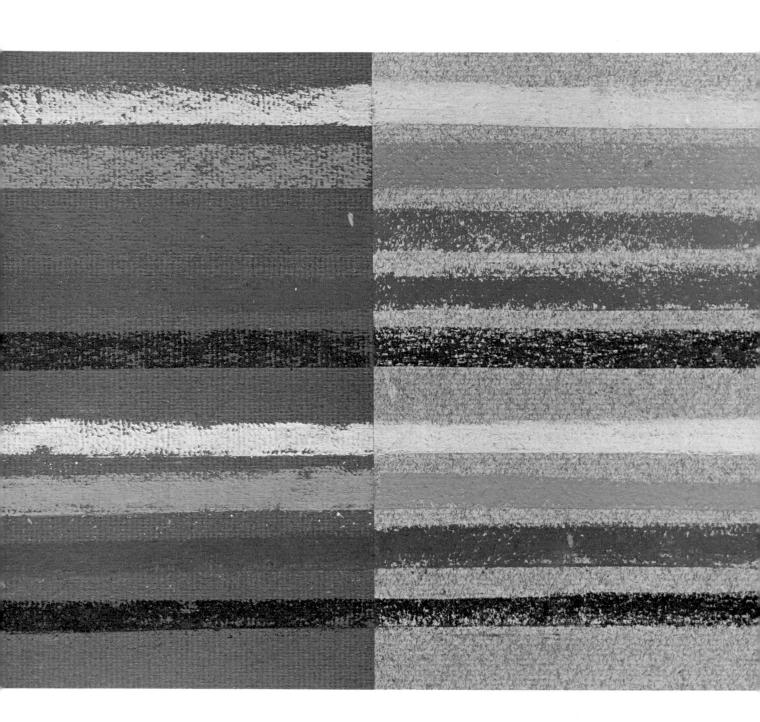

WHAT ARE PASTELS?

Pigments in pastels are the same as those used in oil and watercolor paints. The difference is in the manufacturing process. Oil paints are made by mixing finely ground pigment with oil. Watercolors are made by mixing pigment with gum. Pastels are made by mixing pigment with chalk and water to make a stiff paste. The paste is then pounded to remove air and formed into long, round or rectangular strips. The strips are cut into short lengths and dried.

Most manufacturers add a binding material to hold the powder together in short sticks. The quanti-

ty of binder in the mixture can affect the strength of the sticks and the quality of the marks.

The strength of color in a pastel is determined by the amount of chalk mixed with the pigment. A lot of chalk will produce a pale tint, and a little chalk will give a dark tint. There is a range of tints within every color. Pastels are graded from tint 0 for the palest up to tint 8 for the darkest.

The top five rows of color in the illustration above are burnt sienna, starting with tint 0 at the top, followed by tints 2, 4, 6 and 8. The lower four rows show tints 0, 2, 4 and 6 of purple-gray. I drew these tints across two shades of gray paper to show how different tints appear on different papers.

Equipment

I use pastels with a velvety texture. Throughout the book I refer to a range of colors and tint numbers. The range consists of 6 tints of 52 colors.

HOW MANY PASTELS?

I am often asked how many pastels are necessary to produce satisfactory paintings. A generous assort-

ment is best because it is frustrating to lack the right tint when you are painting. You have to compromise and use the nearest tint, or adjust colors already applied on the painting.

You can mix a tint to some extent by applying one color on top of another. You can make a pink tint by covering red with white pastel, but this solution is crude.

- A Box 96 pastels assorted
 B Box 72 pastels assorted
 C Box 36 pastels landscape
 - D Box 24 pastels (soft) portrait
 - E Aerosol fixative workable
 - F Aerosol fixative glossy finish
 - G Pad of pastel paper
 - H Assorted pastel paper
 - I Drawing ink
 - J Pastel container
 - K Used pastels on table
 - L Willow charcoal
 - M Hog bristle & sable brushes
 - N Kneaded rubber eraser
 - **O** Pencils
 - P Spray diffuser
 - **Q** Bottled fixative
 - **R** Fixative mat finish
 - S Fixative mat finish

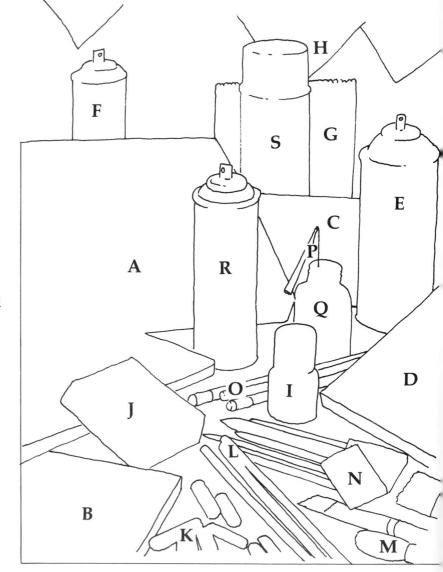

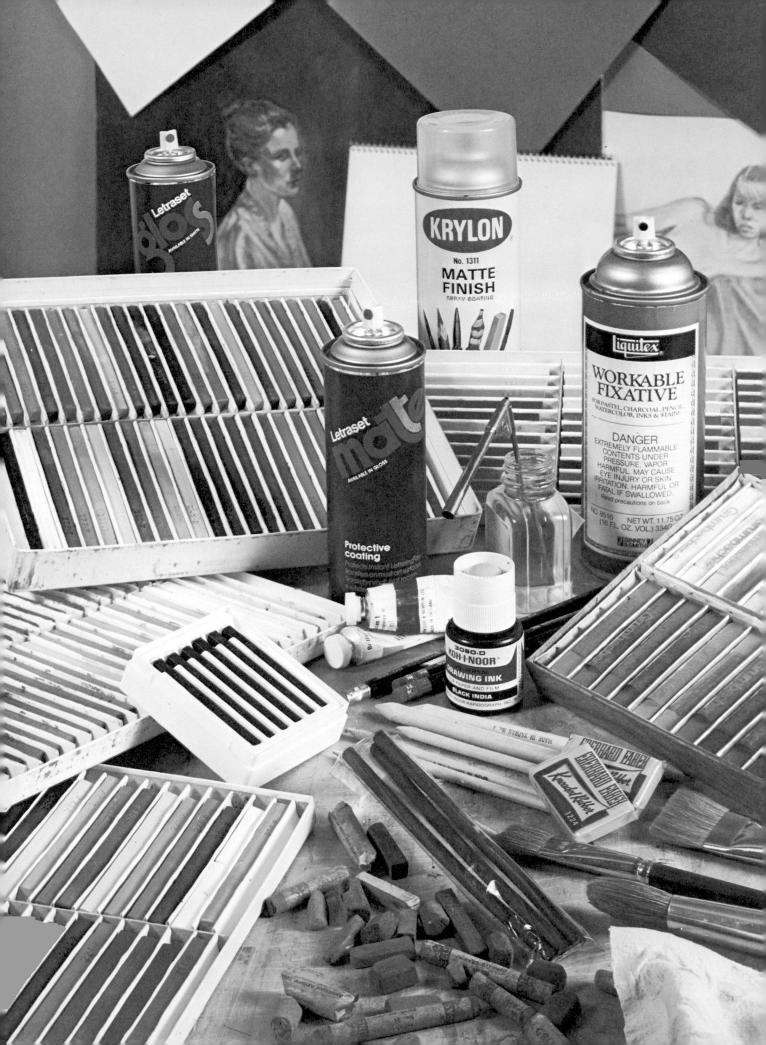

Pastels are available boxed in sets or individually. Boxes contain 12 to 100 pastels. Special selections are available for landscape or portrait painting.

You should select pastels according to colors, not by names. Sometimes the names give a good idea of color subtleties, such as blue-green, yellow-green, olive-green, purple-gray or purple-brown.

Begin with a modest selection if you are just starting to paint with pastels. A basic selection should include yellow ochre, cerulean blue, cadmium red, red-gray, purple-gray, green-gray, warm gray, sap green, burnt umber and indigo. You will need a light, middle and dark tint of each color. Remember, the lightest tint is tint 0 and the darkest is tint 8.

To help you remember tints, make a color reference chart by rubbing each new pastel on a sheet of paper. Write the color name and tint beside it.

STORING PASTELS

You can buy special boxes that have trays to hold pastels. These are useful for storage. Develop the habit of returning each pastel to its place after use. Mark each tray with the proper color. Some painters make containers by lining a shallow box with corrugated cardboard.

Another storage method is to use a small box for each color range. By keeping all tints of a color in one box, you can compare them quickly and select the desired tint.

If you store different colors in a box, fill the box with uncooked rice. The rice prevents the pastels from rubbing against each other. The slight abrasive quality of the rice also keeps the pastels clean. The rice should be replaced occasionally.

I don't store pastels this way. I prefer to leave them lying on the table while I work, all colors mixed together. You may prefer to adopt a more organized way of working.

I think it is a matter of temperament—I am too impatient to be tidy. I work in long bursts of feverish activity. If I don't immediately recognize a pastel, I rub it on the nearest piece of cloth. This is usually my shirt.

HANDLING PASTEL PAINTINGS

There is a lot of exaggerated fear about pastel paintings getting smudged. If treated carelessly, pas-

tels will smudge. The paintings for this book were handled many times before they appeared in print. Take reasonable care of paintings and don't slide one across another. They can be stored easily in a stack, each separated by a piece of tissue or newspaper.

Loose pastel fragments sometimes flake off a finished painting if it is bumped or dropped. I guard against this by spraying paintings with a colorless fixative for pastels. Fixative comes in bottles and aerosol cans. If too much spray is used, the pastels become wet. The painting will lose some of its brightness.

If I use a thick buildup of pastel, I often paste the finished work on mounting board. I place the painting face down on a clean table and brush synthetic wallpaper paste on the back of the paper. I leave it for 10 minutes to soak in and stretch the paper.

I then pick up the painting and place it on the mounting board with the right side up. Next, I cover it with a piece of newspaper and smooth the paper down with my hand, working out from the center. This requires care. The newspaper should not slip. The paste soaks through the paper and helps fix the pastel. It is necessary to paste a sheet of paper to the back of the mounting board to prevent it from buckling as the painting dries.

I occasionally spray a fixative on the pastel while I work on it. I can then apply another color over the fixed pastel without disturbing it much. I leave some of the first layer uncovered to give a broken, two-color effect in the painting.

EASELS

I stand when I paint because I feel restricted if I paint while sitting. I like to move about so I can step back and look at the work. I walk around and return half a minute later with a fresh eye. This movement helps me quickly recognize errors.

I fasten paper to a piece of sturdy hardboard with clips. Put a few sheets of uncreased paper between the pastel paper and the board. This gives a good, cushioned painting surface and prevents imperfections in the board from showing in the painting.

I usually support the board at eye level on an upright studio easel. A portable sketching easel is equally suitable. It can also be used for outdoor work. An easel has the advantage of holding the painting upright so I can stand away and work at arm's length. I can render broad sweeps of pastel and step up close to paint details. If the pastel crum-

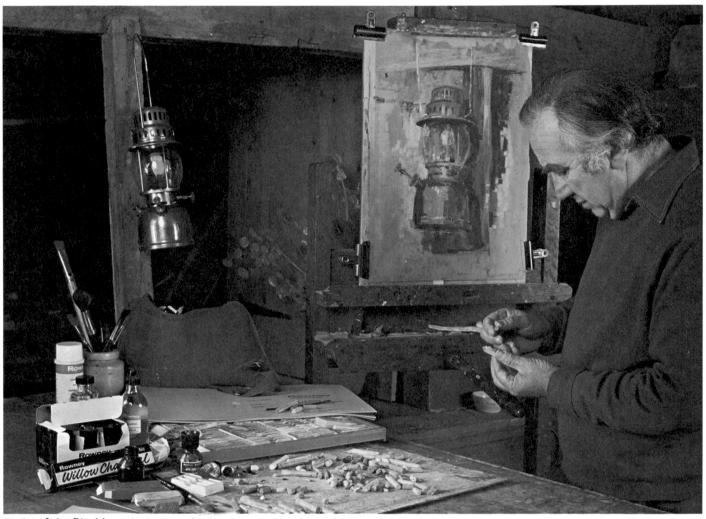

Author John Blockley selects a pastel color.

bles when I press too firmly, the particles fall and collect in the easel's ledge instead of adhering to the painting. An easel also helps you avoid accidentally rubbing against the painting.

If you prefer to sit while working, a portable easel can be adjusted easily to a suitable height. Or you can use a table easel that tilts to various angles. Another method is to lean the painting against a pile of books. a good black line of a texture that is compatible with pastels. Charcoal is easily erased with a kneaded eraser. When you are satisfied with a drawing, flick the charcoal with a feather duster or rag and leave a gray impression on which to paint with pastel.

A kneaded eraser is soft. It can be molded into a fine point. It will cleanly erase pastel. A stiff hogbristle brush is also useful for removing pastel. Mistakes in a painting can be conveniently removed without affecting the paper's surface.

ACCESSORIES

You will often need a pencil, ink or charcoal. Keep at hand a bottle of black drawing ink and some medium-grade sticks of charcoal. The charcoal gives

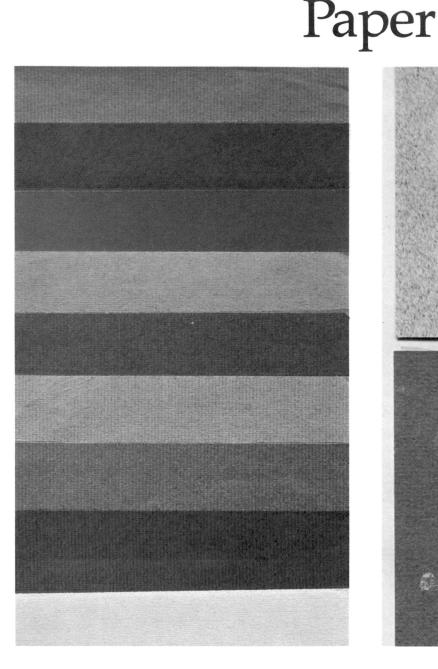

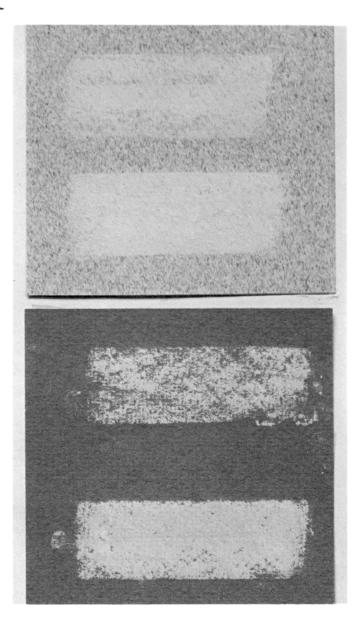

Some pastel artists paint on hardboard, muslincovered board, canvas or even sandpaper. But most work on tinted papers made especially for pastels. I use Italian Fabriano or Swedish Tumba Ingres papers. I like the subtle texture of these papers that enables me to drag the pastel lightly over the surface. The color of the paper shows through and gives an interesting effect. I can press the pastel firmly into the slight texture to obtain solid patches of color.

I advise you to work on soft papers. The rougher surfaces of some papers break up the layers of pastel too much. Rough papers give a coarse, insensitive finish to a painting, but such a finish may help you achieve a desired effect.

I made some pastel strokes on the sample papers above right. The strokes show how paper grain can show through lightly applied pastel or be covered by heavy pastel. Notice the difference in finish between the blue pastel on gray paper and the blue pastel on orange paper. The blue-on-gray is a subtle combination. The blue-on-orange is an exciting, vibrant combination. The vibrant contrast occurs because the colors are nearly complementary.

There are many ways paper color can be used to create a special effect. A cool-gray paper will give a

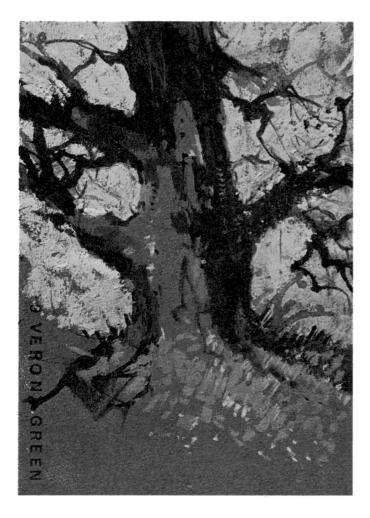

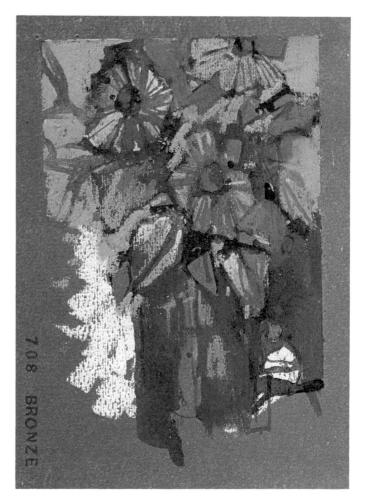

pleasing background to a painting composed of pink and gray-green colors. The result will be a restful, easy-to-look-at picture. Brilliantly colored pastels will make a striking picture when painted on brightly colored or dark papers.

The color *value* of the paper is important. The term value refers to the lightness or darkness of the paper's color. Dramatic effects—such as a brilliant light sky behind a dark mountain—can be obtained by using light pastels on dark paper, or vice versa.

Over the years, I have discovered I can work better with a middle-value paper—not too light or dark. I use this middle value as a starting point. Against this I can judge the value of color I want. I can determine if the pastel should be lighter or darker than the paper.

I find it easier to judge how light or dark a color should be when working on middle-value paper. It is more difficult when working on a light or dark paper. A middle-value paper can also reduce the work required because part of the paper can be left unpainted. Dark paper can help if the subject is generally dark.

PAPER COLOR

The range of paper colors allows you to choose a painting surface that will be compatible with a subject. If a subject is mainly green, you can use a green paper and leave parts of the paper unpainted. This allows the paper to represent part of the subject.

My tree painting above on the left was done on Verona Green Fabriano paper. I left the paper uncovered for the foreground and the light parts of the trunk. It is only a small sketch painted on a sample piece of paper. Small sketches can be effective by taking advantage of the paper color with only a little pastel work. I relied mainly on three pastels: cerulean tint 0 for the sky and sepia tints 5 and 8 for the dark parts of the tree.

The flower painting above was also made on Fabriano, this time bronze. I used the paper color for the flowers, with just a few touches of lemon yellow tint 2 on the petals. The color of the paper is allowed to show, uncovered, in other small parts of the painting. This is a small, stylized sketch, with simple, patterned shapes. The pastel medium is ideal for this type of painting. It can be pressed onto

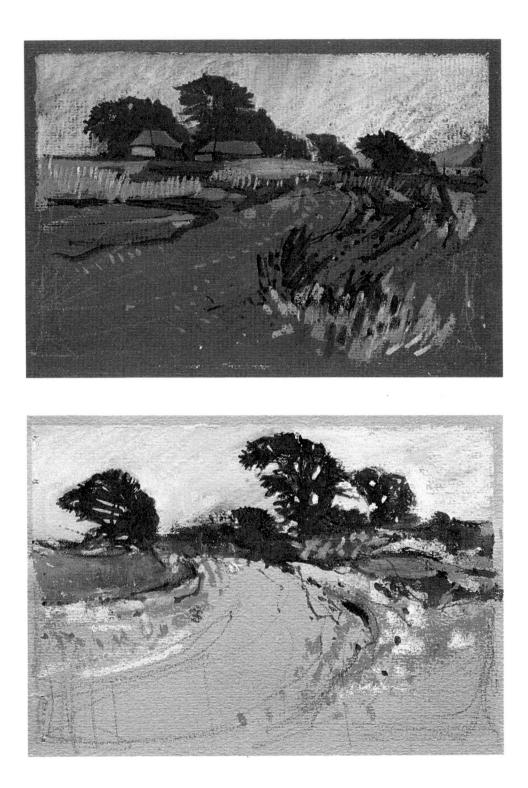

the paper to make patterns of opaque color, as in the blue background, or applied gently, as in the petals.

The simple landscape paintings above also leave large parts of the paper uncovered. The pastel work is confined mainly to the sky and trees. Most of the bottom half of the paper is unpainted. I used the same pastels in both paintings, but on different colors of paper. I used Sienna Brown Fabriano paper for the top painting and Sand Fabriano Ingres paper for the bottom one. The pastels used were cerulean tint 0 and blue-gray tint 0 for the skies, and olive green tint 2 for the grass. The trees are burnt umber tint 6.

You should experiment by painting simple landscapes on various colors of paper. At first use only a few colors. Use the same colors I did, then try a combination of your own choice. You should avoid

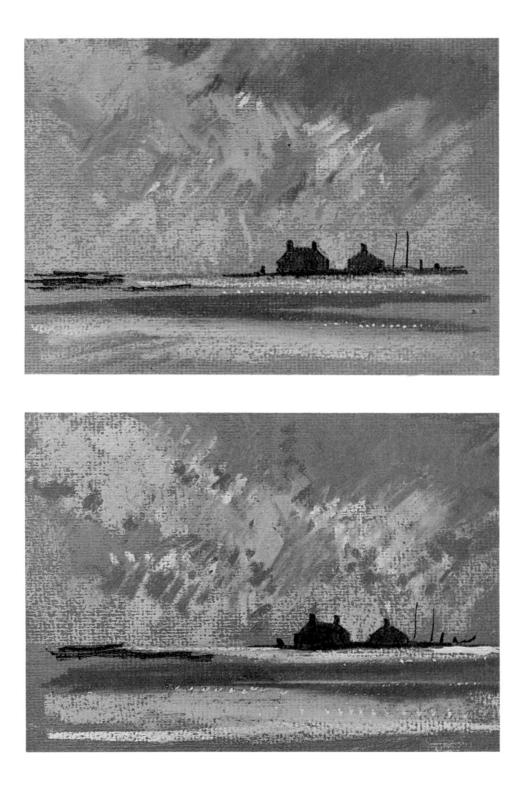

bright colors for these first experiments. Keep the pastel colors subtle so the color of the paper will dominate. The purpose of the experiments is to discover how much you can take advantage of paper color.

The top painting above was made on Fabriano Stone Gray paper. The bottom one was painted on Fabriano Verona Gray. I used cerulean tint 0 and blue-gray tints 0 and 2 for the sky and water. I chose charcoal for the cottages and allowed the paper to show in both paintings.

Which paper would you have chosen? It really depends on the mood you wish to portray. The stone gray complements the color of the pastels. They combine to produce a restful mood. Although I used the same pastels in both and applied them in the same way, the green paper is less compatible with the pastels. The green creates a vibrant mood.

How To Apply Pastel

The basic pastel strokes on the opposite page were made on Bronze Ingres Fabriano paper. The first two horizontal strokes at the top, labeled A, were drawn with a short piece of red-gray tint 2. I firmly pressed the side of the pastel onto the paper and dragged it sideways, as shown in photograph No. 1 at top right. Notice how the texture of the paper shows through the pastel. The band below is red-gray tint 0, firmly pressed to fill the grain of the paper.

Alongside these color bands are short, diagonal strokes of red-gray tint 0 pastel, labeled D. They were applied loosely to allow the color of the paper to show between them. I overlapped these with similar strokes of red-gray tint 2. A *rubbed* combination of the two tints is produced where the two pastels cross. Original, unmodified strokes occur elsewhere. A broken-color effect—combined with bits of blended color—is produced in B and E. The process can be expanded to include additional tints of the same color or another color.

I repeated the exercise with the same pastel tints, but using the end of the pastel to draw lines rather than bands in photograph No. 2 at right. In exercise C on the opposite page, I superimposed dots of cobalt-blue tint 2 over dots of lizard-green tint 1. This is shown in photograph No. 3 at right. I combined the processes—overlapping dots, lines and bands of color—in exercise F on the opposite page.

Experiment with these techniques. Use different combinations of colors and tints with various colors of paper. Vary the pressure of the pastel so the color of the paper sometimes shows through the pastel strokes. You will discover how heavy pressure on a pastel stroke affects the layer underneath. Heavily cross a line of gray with pink pastel and see how the pink will drag some of the gray with it.

This technique, called *cross-hatching*, was used often by Degas. His original paintings show remarkable results from overlaying pastel strokes of varying lengths. He put short strokes over longer strokes, hatched diagonally, vertically and horizontally. He combined strokes with dots, sometimes crisp and sometimes blended. The flesh colors of his figures seem to shimmer with light.

These methods of applying pastel are exciting to use. They can produce vibrant effects. Practice to

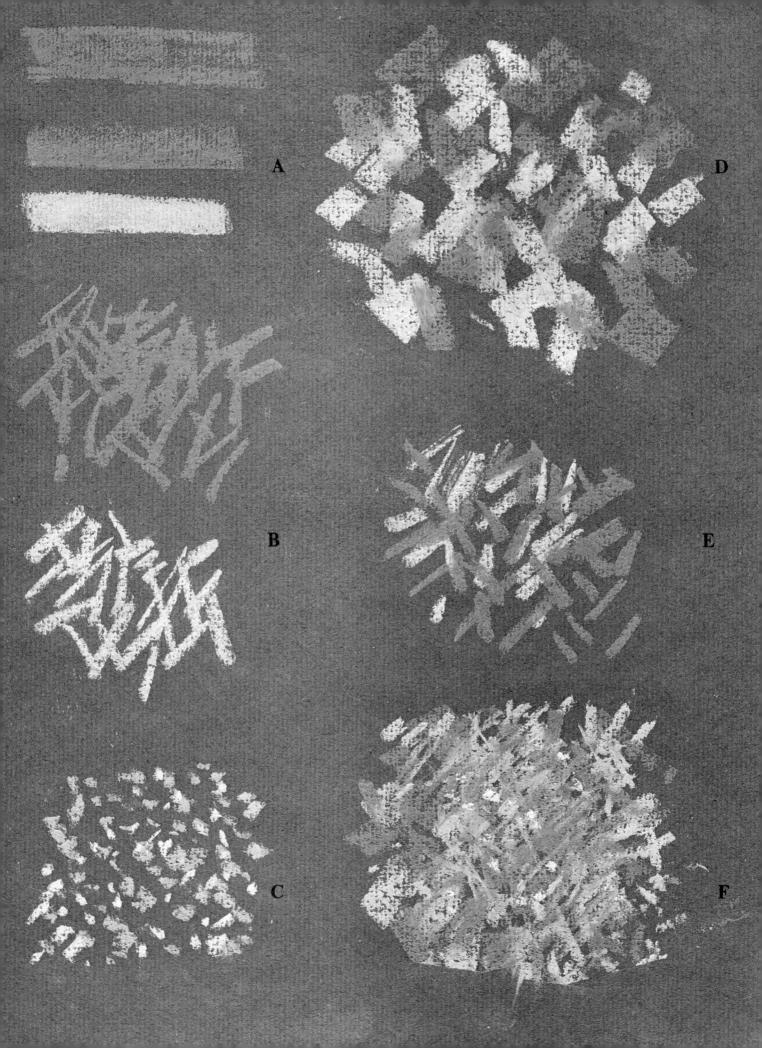

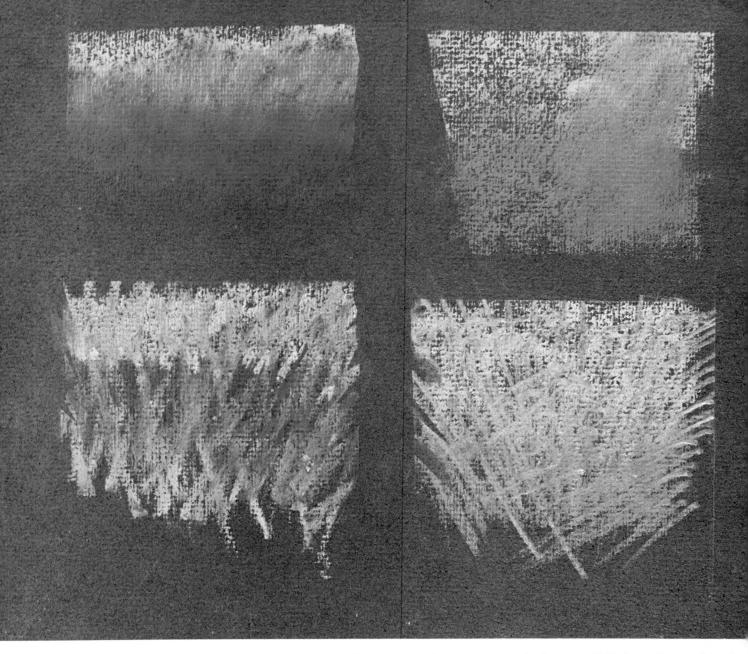

see what you can do. Do not paint pictures for this exercise—just draw lines and bands in all directions. Overlap them, make big dots with heavy pressure and small dots with rapid stabs of the end of the pastel. Practice as many ways of applying pastel as you can.

RUBBING PASTELS

Smooth pastel work can be produced by *rubbing* with your finger to blend colors. This technique may lead to an overworked, dull painting. The pastels may lose the fresh appeal. Freshness is unique to the pastel medium. It is caused by granules of pigment reflecting light on the paper.

Although freshness can be destroyed by rubbing and smoothing the pastels into the paper grain, the process is used by many painters. You must decide what type of surface you like. I strongly recommend you keep the rubbing technique to a minimum until you have explored the possibilities of unrubbed pastels.

The sparkle of unrubbed pastels is a unique property of the medium. I like to exploit this sparkle. If I rub the pastels at all, I do so only enough to blend colors slightly. I use the technique only as a contrast to textured pastel work.

Examples of rubbed pastels are shown above. At the top left is a band of lizard green touching cadmium red. I blended the two with my fingertip. Alongside, I repeated the exercise with bands of lizard green and olive green. I rubbed the right side to fill the paper grain. I repeated these color bands below and hatched through them with blue-gray partly to blend them. This resulted in a more vibrant effect than rubbing alone produces.

The mountain landscapes on the opposite page are similar in content. The top example is rubbed and the bottom one is not.

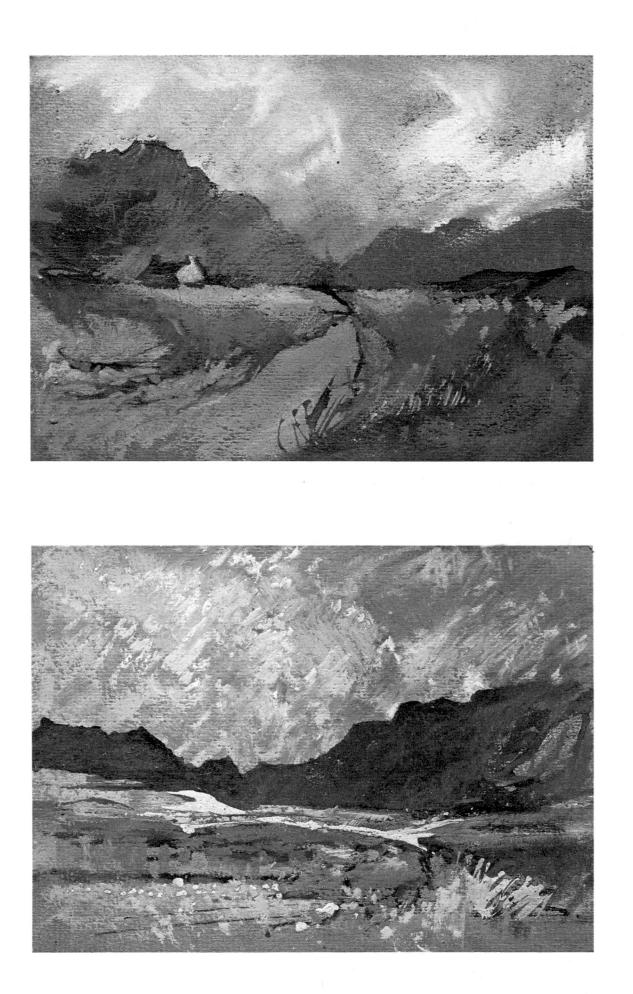

Frequent sketching outdoors is enjoyable and has great practical value. Sketching makes you observe and compare proportions of objects. You can concentrate on objects without the distraction of color problems and painting techniques. This concentrated effort also builds a store of information that will help when you paint.

here

Sketching

Sketches also provide visual references from which to paint. The important thing is to make sure you collect enough information for paintings when you return home. The sketch should be complete, or should include written notes to aid your memory.

I sketch mostly with a pencil, sometimes with a few pastel strokes. Over the years, I have collected many sketches. A few of them are included in this book. They also have nostalgic value. They remind me of enjoyable days in interesting places.

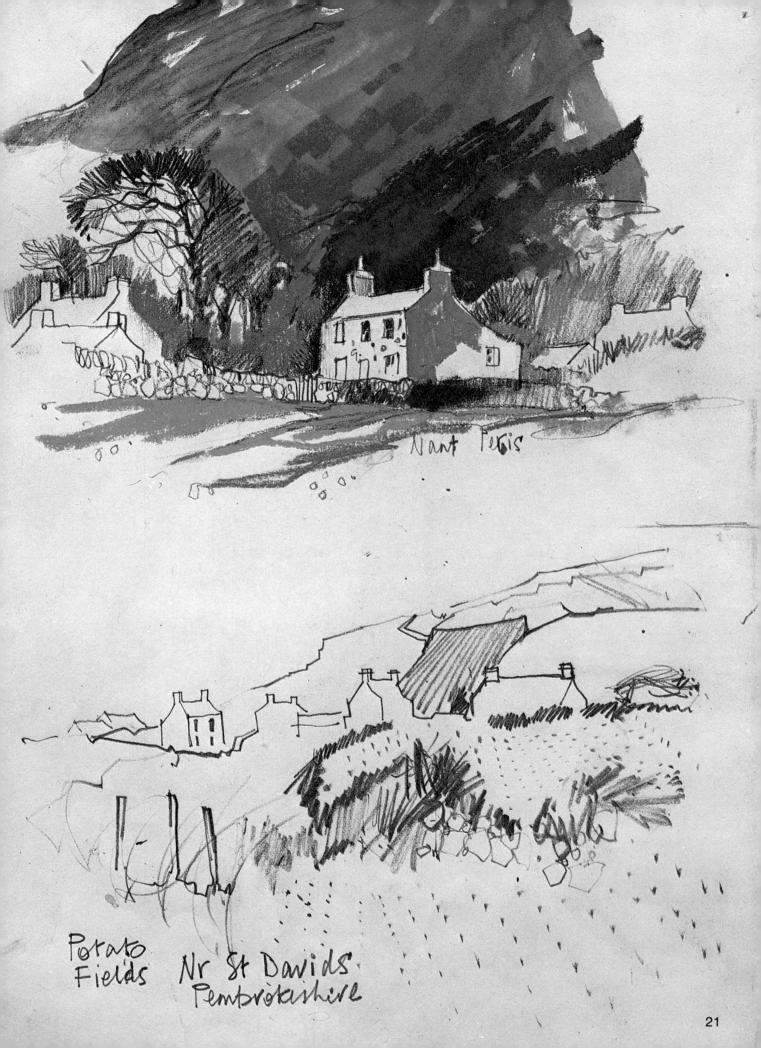

Painting Figures

People are fascinating to paint. Wonderful characters are everywhere. I love to make pastel studies of people, concentrating on their attitudes rather than facial likenesses. Tall, thin, drooping figures and short, almost spherical figures are interesting to observe and paint with slight exaggerations.

I like to watch people going about their normal activities. It is not always easy, or perhaps wise, to study the people around you too obviously. But you can look long enough to mentally record the essential characteristics, aided with a small sketch.

The thought of painting figures can deter the inexperienced painter. But some pictures need a few figures. Imagine a street scene without people. The figures for such a painting are usually just elements within the whole scene. They are a small part of the painting. If you realize this, the fear of painting figures will begin to disappear.

It is often easier to paint a group of figures rather than just one. My small, rough sketch at right was quickly done with the end of a brown pastel. I placed one light shape within a darker group, indicated the heads and flicked downward strokes for the legs. The sketch is a convincing group of figures suitable for a street scene.

I chose to do a little more drawing for the lower figure—just enough pastel lines to indicate the man with hands in his pockets. The drawing is not much more than an outline. I did not draw the feet because I was not interested in them for the overall effect of the sketch. I gave substance to the drawing by filling in the background with varied pastel strokes.

My painting on the opposite page suggests three figures on a shopping trip. I tried to make the nearest figure more important by making her larger than the others. I contrasted her light, yellow-green coat against a darker coat. I inclined the heads of the other two figures toward the first. I did not indicate facial features because I was not interested in showing eyes. But I did want to emphasize the dominant figure.

Try to capture the mood and activity of figures. I did not draw their legs very well because they were not necessary.

Draw a few simple figure groups. See how convincing you can make them with a minimum of drawing. Use a piece of charcoal or pastel so you will not have to worry about drawing small details.

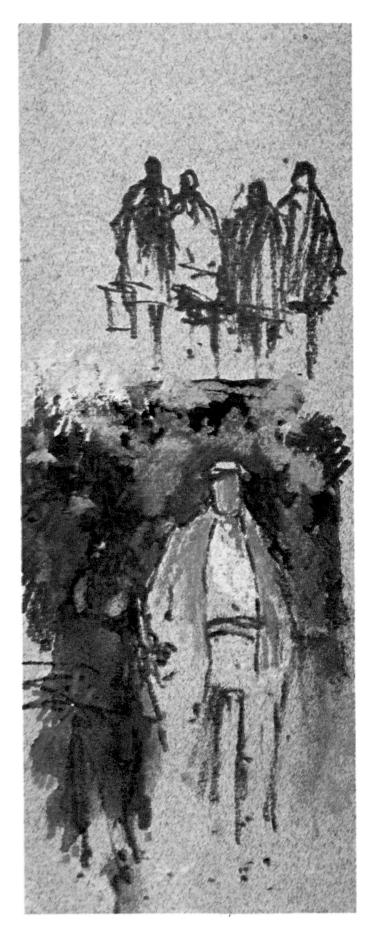

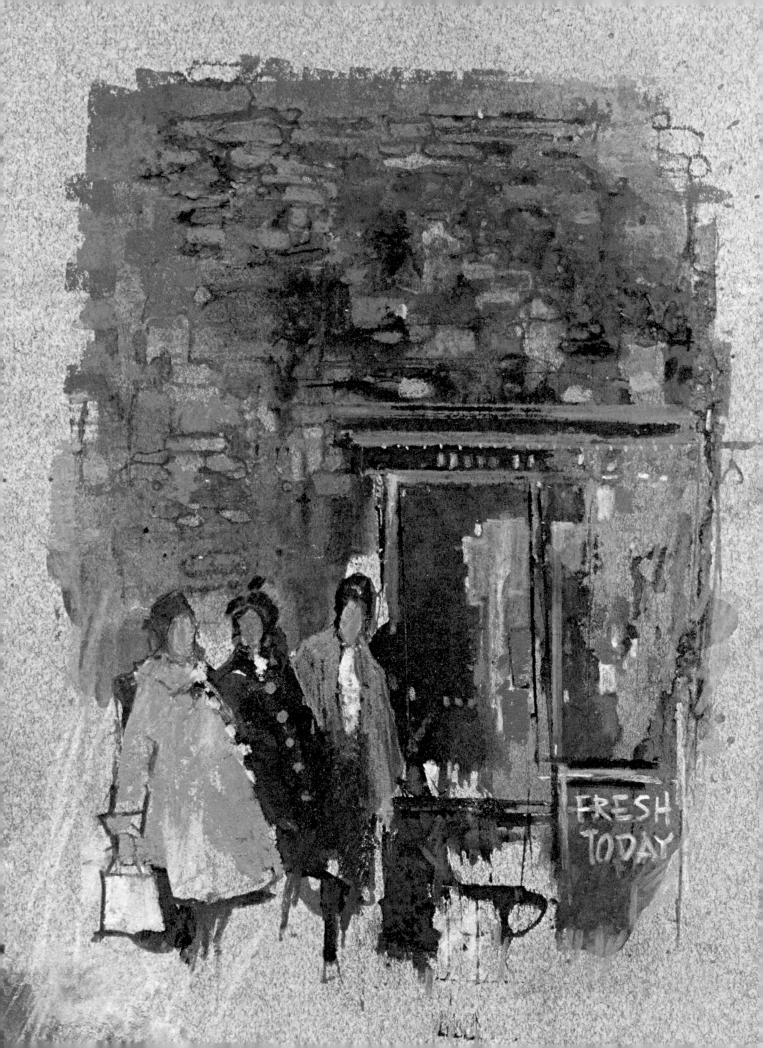

Moorland Cottages

This painting summarizes what I have discussed so far. The illustrations on the opposite page show the painting at both an early stage and finished stage. I wanted a dramatic effect of dark stone cottages silhouetted against the light part of the sky. I chose a fairly dark paper, Fabriano Mid Gray.

The cottages were placed high on the paper to make them important, and to leave plenty of space below for elaborate foreground textures. I drew the outline of the cottages with a black pencil and immediately added some sky color with yellow ochre tint 0. This light pastel leaves the gray paper exposed for the cottages—a good example of effectively using paper color.

I left the sky unfinished and started to develop the foreground. I made pastel strokes of various colors, using short, quick strokes and longer, lighter strokes with dots. I developed the foreground with these varied pastel marks. Some areas were painted with sepia tint 8, pressed into the paper to make dark passages to enhance the lighter parts. In some areas, I twisted the end of a light pastel onto the paper surface to make abstract, mottled light shapes at the bottom left of the painting.

I was concerned about maintaining a dramatic sky, so I kept the colors of the foreground fairly muted but elaborately textured. Too many strong contrasts of light and dark in the foreground would have conflicted with the sky. For this reason, I avoided the vibrant effects of cross-hatching in this painting.

The light yellow ochre in the sky was applied with enough pressure to fill the paper grain. I wanted an intense area of light, so I covered the paper. The light sky is further emphasized by the dark indigo used for the upper sky. I contrasted the yellow ochre with short, broken cloud drifts of light and medium gray.

Using a different technique in an adjacent area is a useful way to draw attention to part of a painting. This painting, with its textured foreground and dramatic sky, was not an easy subject. But it shows interesting applications of pastel.

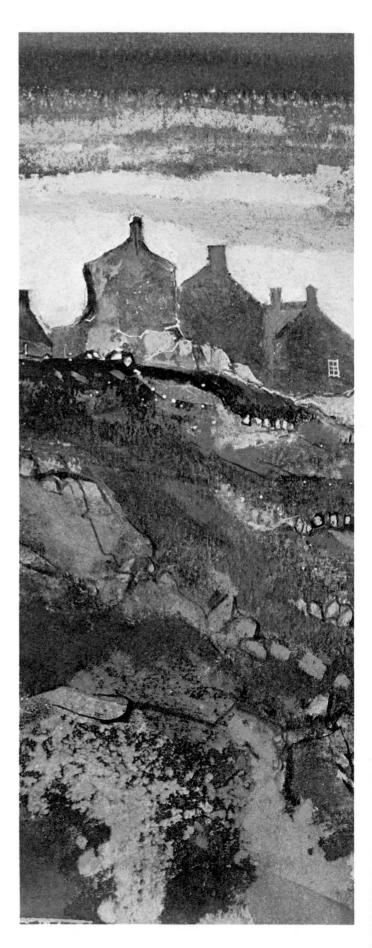

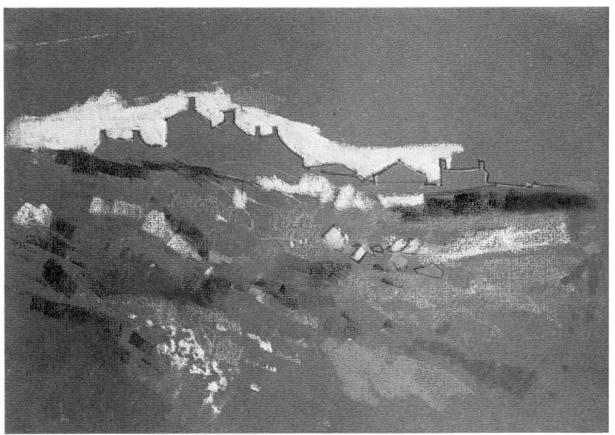

Early stage

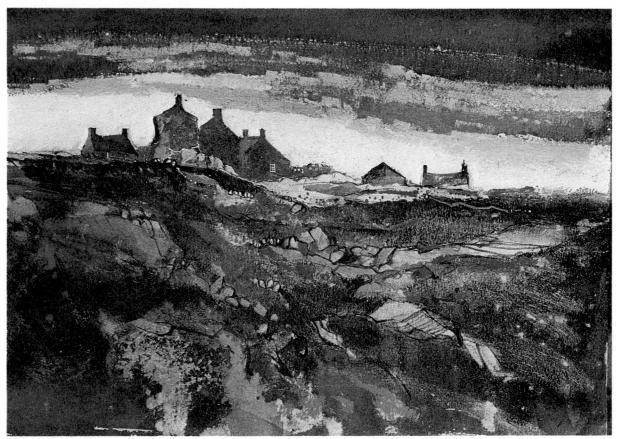

Final stage

Cottage Details

I liked the details of the windows of this cottage. I was interested in the door that opened into the cottage. I made some pencil sketches and painted from them at home. The two men are imagined, although I am sure I have seen them somewhere.

The upstairs dormer windows are located in the slope of the roof. The whitewashed walls on each side of the windows make a good pattern of light, vertical strips against the bulk of the roof. Some of the window panes are dark and some are light.

The downstairs window is set back into the thick wall. Windows are often incorrectly painted flush with the front of the wall. I took care to show how the upper part of the sash window overlaps the bottom half.

The walls of the cottage were whitewashed but had weathered to reveal layers of previous colors pink and ochre. I obtained this effect by crosshatching the colors over each other.

I painted the tree carefully and only hinted at detail in the top branches. An elaborate tree would have detracted from the window detail. I painted only enough detail to make the tree look convincing. I understated the gate and wall details.

The door is a simple subject that I painted merely as an exercise.

The actual building was unpainted. I liked the colors of the stone—warm gray with hints of red and blue, stained from rain and covered with green moss. The textured stone contrasts well with the plain door. The texture was obtained by dragging the side of the pastel over the paper, and by pressing dots of color into the paper with the end of the stick.

The door is rubbed pastel: lightly applied red, gray and green, smoothly blended with my finger to contrast with surrounding texture.

The shadow at the top of the door is important. I painted it with sepia—not black—applying firm pressure to the paper. Sepia, or any dark brown tint, gives a good, warm dark. Sepia is more subtle than black.

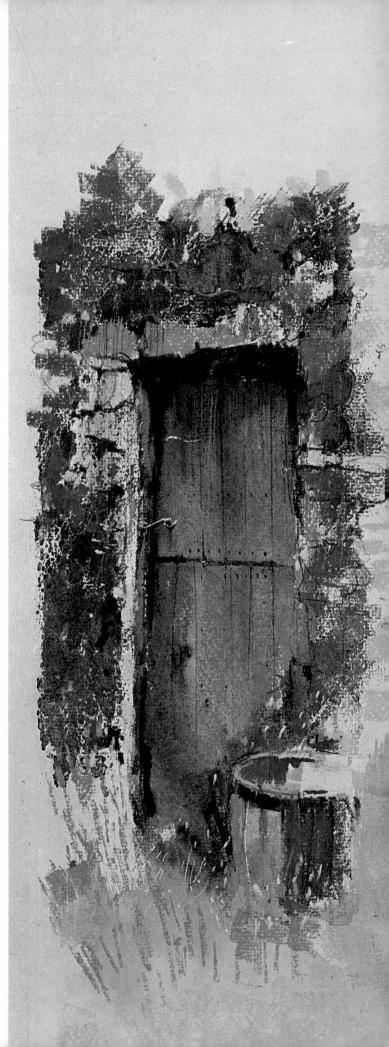

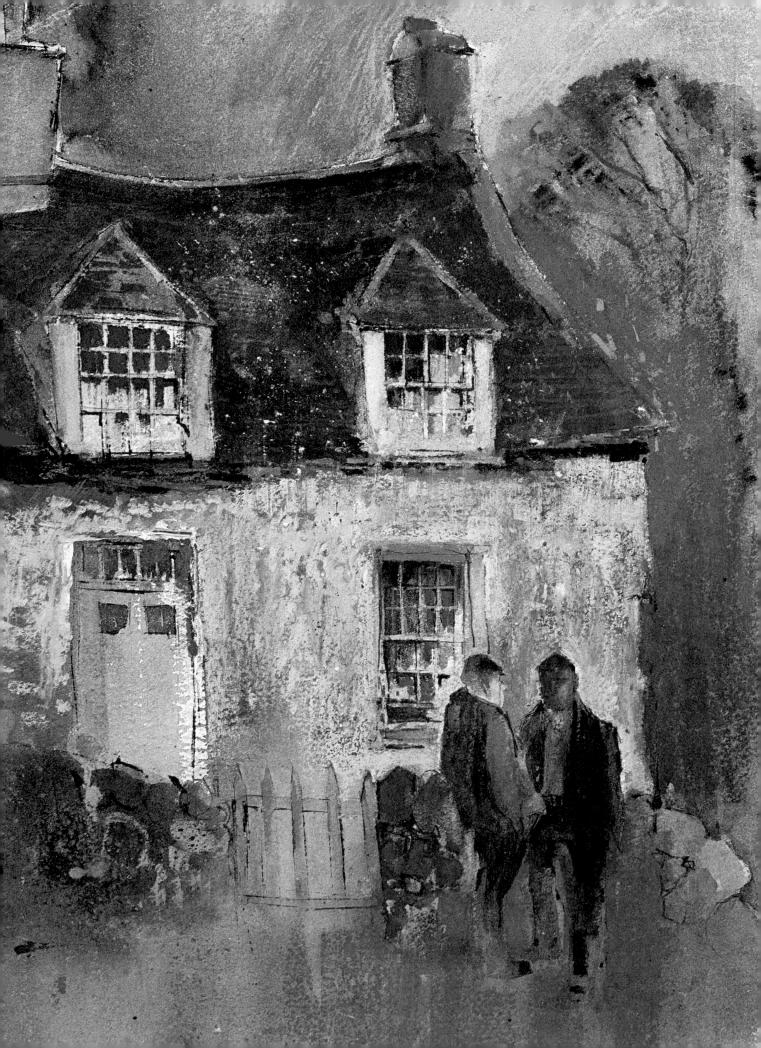

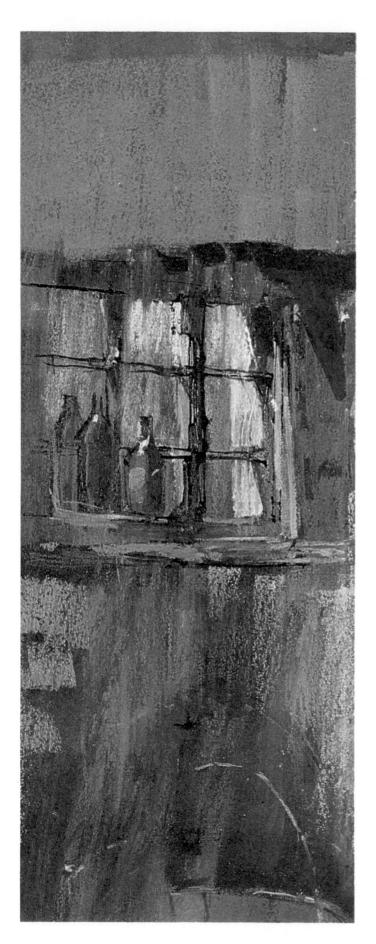

Cottage Interior

I walked into the cottage to make a pencil sketch for this painting. I used Tan Fabriano Ingres paper, letting it show through in many places.

I enjoyed painting this scene with its mysterious darks and flickering highlights. With subjects like this, you paint only what you see—glimpses of cans, highlights on bottles and glints of light on objects that are indistinguishable in the dark interior.

It is impossible to analyze all the objects accurately. Pastel, though, is an excellent medium for capturing impression. The opaque pigment makes excellent accents of color on dark paper.

I used the darkest tints of Vandyke brown, purple-gray and purple-brown for deep shadows. I applied them in slabs of color with side strokes. Some were shaped with hard edges to form cast shadows. Others I blended together to form soft depths. I used lighter tints of these colors for the paler shadows and middle values. I used touches of poppy red, sap green and blue-green for the brilliant lights on the bottles.

I wanted some detail in a few places, such as the window, the large buckets, the corner of the shelves and the bench. I also added definition to some of the smaller objects on the shelves and included my oil lamp in the painting. The lamp gives a hint of definition within the impressionistic treatment.

These early stages of the painting were made with side strokes of pastel. I then added the light part of the wall by drawing strokes with light tints of cool gray, blue-gray and Naples yellow. For this I used the end of the pastel, cross-hatching the colors over each other.

I lightly flicked downward lines of cool gray over most of the painting to break and blur the edges of many features. Many of the colors are dragged into one another. Blurred edges give a feeling of half light inside the building, where objects are not clearly seen.

The important thing to learn from this painting is that details can be limited to a few objects. You can rely on flicks of color to suggest detail. Most edges are soft, but here and there a few crisp edges emerge and then blend away. A large part of the painting is concerned with *suggested* detail.

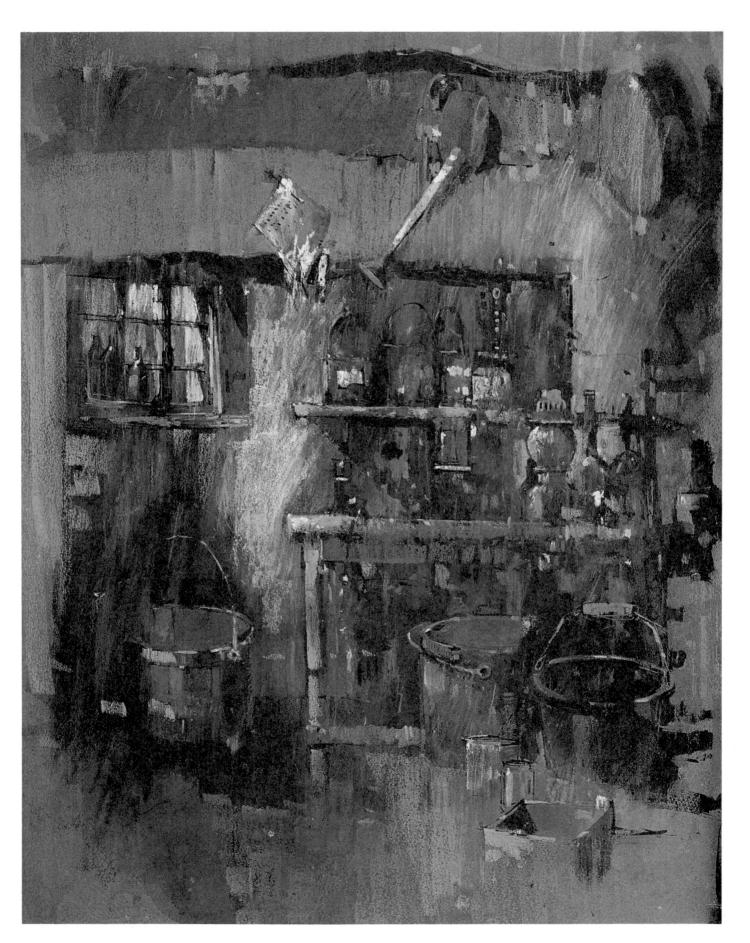

Anglesey Cottages

These cottages, with their chunky shapes, were ideal painting subjects. The whitewashed walls gave excellent tonal contrasts. Pastels were applied in a direct, unrubbed manner to suggest the simplicity of the cottages.

The full-size details on the opposite page show how the white pastel was applied in direct strokes. This method allowed the paper to show through to suggest the stone's texture.

Notice how the chimney at far left in the painting below looks like a solid cube of white stone without ornamentation. I painted the white side with one broadside stroke. The Fabriano Tan paper shows through in the steps and parts of the foreground.

With charcoal, I outlined the cottages, steps and stones at the side of the steps. The drawing expressed shapes in the subject. The rest of the painting is almost abstract. This abstraction is especially important in the irregular foreground shapes. I did not show foreground details because I wanted to concentrate on the steps leading up to the white cottages. I want the viewer to walk up those steps, so I emphasized the stones on the left. I also tried to attract the viewer by pressing the pastel hard into the paper to intensify the white on the right end of the cottage at left.

Every time I make a pastel stroke, I consider its purpose. I decide if I want to draw attention to it. The stones to the left of the steps are hard-edged. They contrast in value, and are outlined. But the stones to the right are subdued, so they do not detract and cause the eye to jump from one side to the other. This sort of planning becomes instinctive with practice and by always considering each stroke.

Painting is concerned not only with methods and technique, but also with ways of seeing and thinking. Choose aspects of a subject that interest you. Discipline yourself to concentrate on one message.

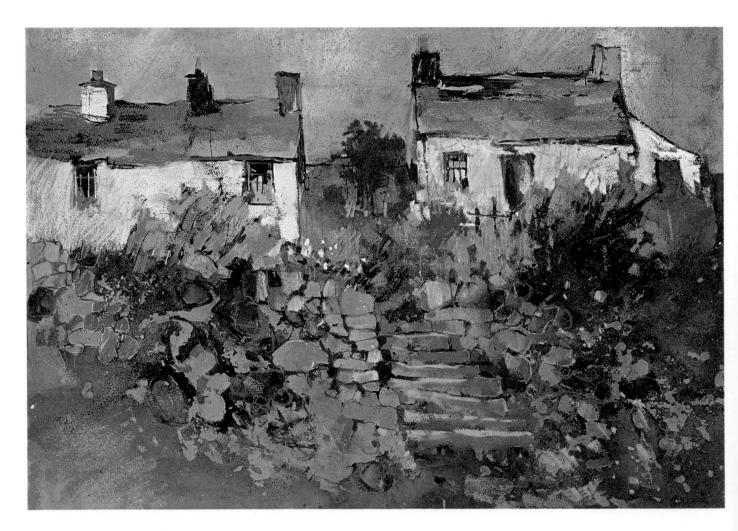

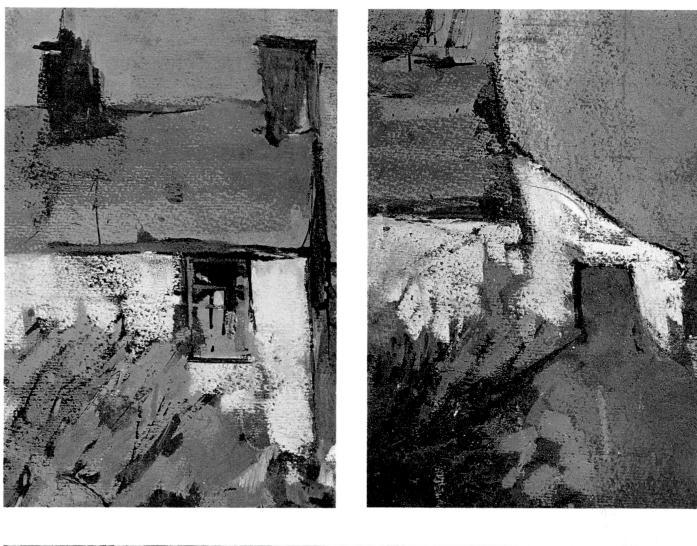

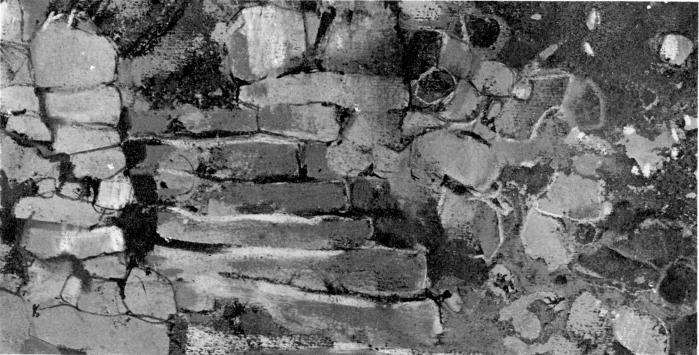

First stage

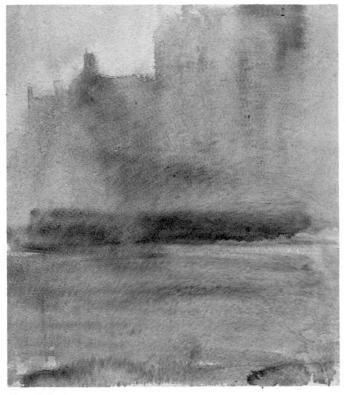

Second stage

Staithes, Yorkshire

So far, I've discussed working on paper made especially for pastel painting. Now I want to discuss papers you can tint yourself.

Good-quality drawing or watercolor papers can be tinted with watercolors. You can tint the paper with one color or several. Paper can be tinted gray at the top—as an underpainting for a pastel sky—and the lower part can be painted with raw umber for the ground. In the painting at right, I expanded the process by applying a misty watercolor to use as a base for a pastel painting.

First Stage—I penciled the outline of the building on a not-too-rough piece of watercolor paper. I did this lightly so it was barely visible. Then I brushed a mixture of raw sienna watercolor and water over the paper. While this was wet, I brushed a mixture of cobalt-blue watercolor on the top left corner and a weaker mix of the same color on the bottom half of the paper. While the paper was still wet, I added some brushstrokes of burnt umber, raw sienna and light-red watercolor in the middle. Some of these brushstrokes can be seen in the finished painting as soft-edged, shadowlike color.

Second Stage—I mixed burnt umber and cobaltblue watercolor with a little water, and brushed this mixture into the damp paper to shape the houses. I left the blue sky of the first wash untouched. This stage is where the pencil outline was useful. Painting a shape such as this into a damp wash requires practice, so don't worry if your first efforts are not as successful as you want. It is not necessary to produce a perfect watercolor painting. You need only to produce a change of color—gray-brown for the general area of the buildings and blue for the sky. Then you have a base for painting with pastel.

Final Stage—I started to apply pastel over the misty watercolor impression by slightly emphasizing distant chimneys with various tints of warm gray. I

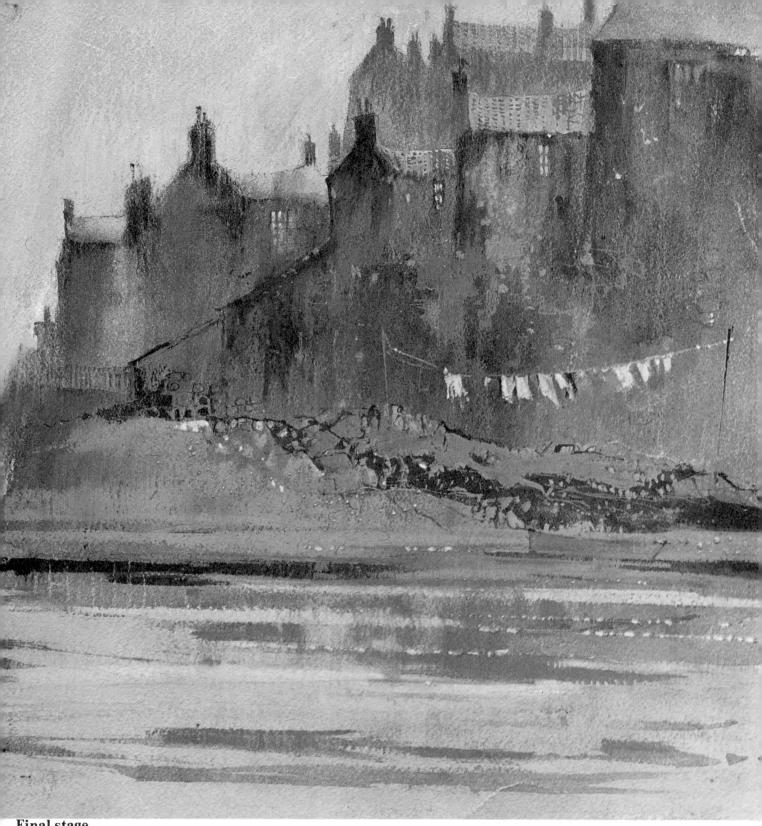

Final stage

dragged some of this color over the general area of the buildings to create stone texture. I defined nearer buildings with purple-gray tints 4 and 6. I allowed a lot of the watercolor painting to show as I concentrated the pastel on the chimneys. This was enough to clarify the nearer buildings, leaving the distant ones less detailed. Then I painted the bright roofs with raw umber tint 1 and touches of madder brown tint 2. I continued to liven up the painting by lightly dragging Hooker's green tint 1 over the sky and water. I used tints of raw umber for the beach, with sepia tint 8 for the dark parts. The water was completed with horizontal strokes of green-gray tint 4 and cobalt blue tint 0. Finally, I drew the boat, added a few varied tints within the buildings, dotted a few highlights and hung the wash on the line!

Low Water

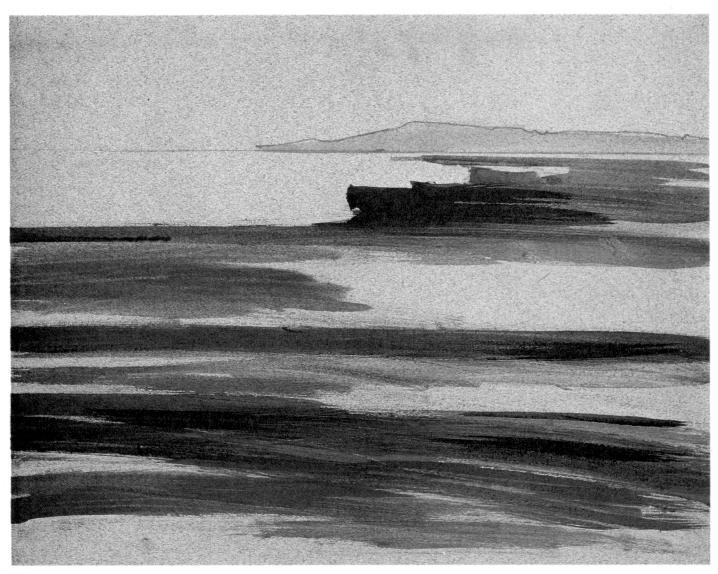

First stage

This subject had strong contrasts of dark and light, so I used a light paper with dark acrylic washes applied first. This approach gave me a dual advantage: a paper surface for pastel that was both light and dark. Instead of tinting watercolor paper as I did in the preceding exercise, I chose a tinted pastel paper—Tumba Purple-Gray. The color of this paper matched the color I had in mind for the sky and water.

First Stage—With a stiff oil-painter's brush, I made dark strokes of acrylic across the bottom of the

paper and in the area of the boats. I used burnt umber, cerulean blue, olive-green, and burnt sienna acrylics. This process requires little or no skill. The brushstrokes are applied quickly and crudely to register the general patterns of light and dark. Acrylics dry quickly and leave a good work surface. Gouache paints, which are similar to opaque watercolors, also give a usable base for pastel work.

The general pattern of the painting was then established. Even this crude image suggested the light colors of water and dark boats.

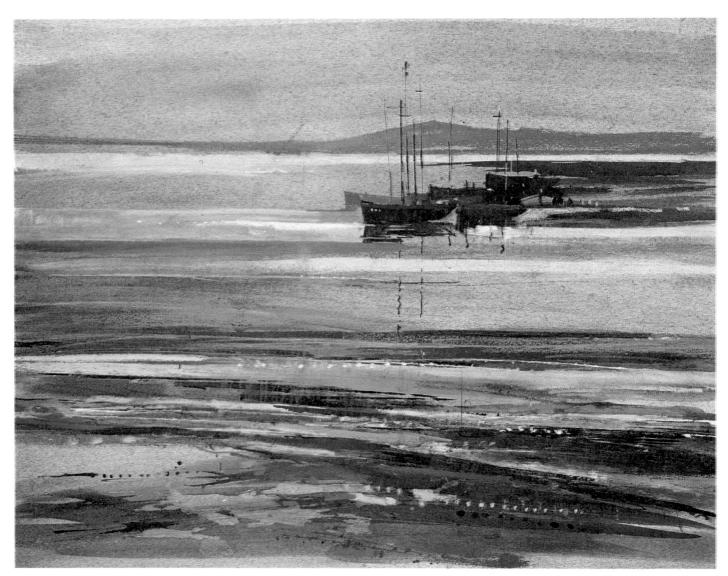

Final stage

Final Stage—I defined the boats quickly by applying light pastel to the surrounding water, leaving hardedged shapes of the dark underpainting to represent the boats. I did not paint the boats themselves. I painted the surrounding water, then added a few touches of burnt sienna pastel to suggest the paint on individual boats. I continued to paint the water by drawing strokes of pastel across the paper with blue-gray tints 0 and 2, cerulean tint 0 and a little white. I left areas of the paper showing. These pastel strokes were applied from left to right with fairly heavy pressure. I continued this treatment in the foreground to make the dark mud and streaks of reflected light. I used Vandyke brown ranging from tint 1, which is almost pink, to the dark tint 8. Finally, with the end of the pastel stick, I made light dots to represent sparkles. I wanted to emphasize the intense contrasts of dark boats and mud against the bright water.

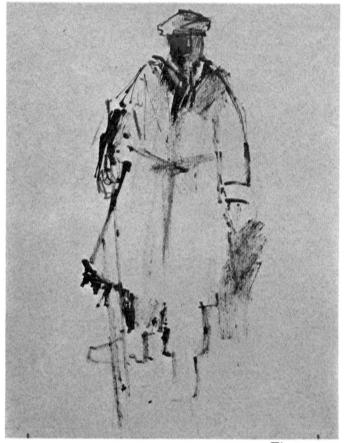

First stage

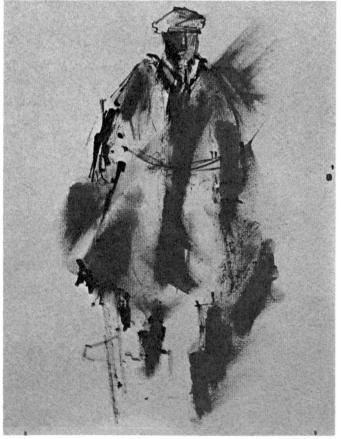

Hill Farmer

This painting was based partly on imagination and partly on memory. I paint a lot in mountainous country, so I frequently meet farmers looking for sheep on the windy, rainy mountainside. I wanted to capture these conditions in my painting.

First Stage—I drew the figure on Blue-Gray Tumba Ingres paper with a blunt wood stick dipped into black drawing ink. When the stick was first dipped into the ink, it produced a dense black line. But the stick quickly absorbed the ink, so the line became gray and broken.

Second Stage—While the ink was still wet, I smudged parts of it with my fingertip to create black patches. The idea was to have paper that was gray in parts and black in others. You can see the reason for this in the final stage. When the ink was dry, I started to block in the pastel background with strokes of gray-green, indigo and burnt umber. I added touches of these colors and raw sienna to the coat.

Final Stage—In this stage, I really made use of the ink drawing. I dragged madder brown tint 2 over the dark ink in the face. I applied burnt umber tint 8 over the light side of the face. This intensifies the brightness of the light pastel by allowing the black ink to show through. The hands and other bright accents in the painting are emphasized by dragging light pastel over black ink. I was careful to apply pastel in gentle strokes so the black ink was not obliterated.

I wanted some dark, hard-edged shapes in contrast to the bright highlights. So I painted the cap, trousers, boots and parts of the coat by pressing the pastel firmly into the paper. It is important to have solid, blocked-in shapes such as these as a base for the loose pastel strokes elsewhere. As I painted the boot, I carefully shaped the heel. I think small, accurate shapes such as the boot give a feeling of detail within the general impressionistic style of the painting.

Then I created the rain across the painting. This could not be done tentatively. I avoided any fear of spoiling the work by vigorously painting lines of pale gray across it. They cut across the figure, breaking up the edges. The form of the figure is partly lost in the rain.

Second stage

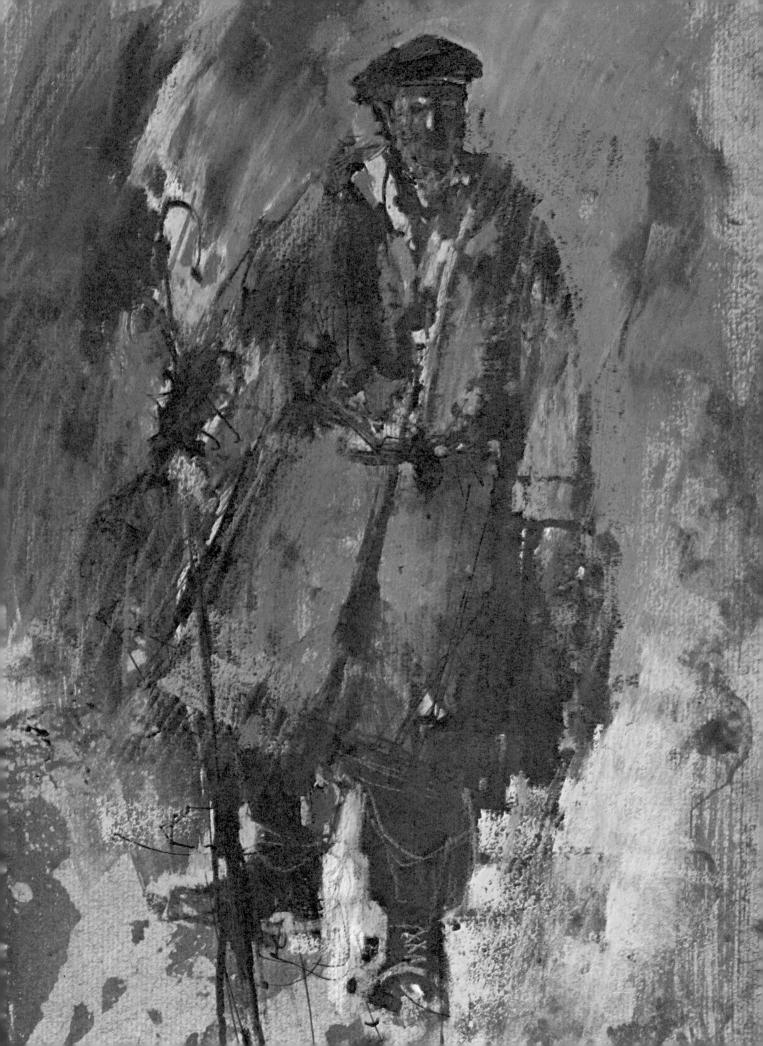

Portrait

Portraits are often painted with almost photographic accuracy. Pastels are suitable for this type of finish. Pastels can be rubbed into the paper to give a smooth surface and to blend colors for subtle gradations in flesh tones. This method was favored in Victorian times, and some painters continue this polished treatment today. I prefer a less-finished surface. I like to see pastel applied with open, unblended strokes. The skill lies in accurate judgment of color and value of nearby strokes. If they are correctly chosen, the strokes will lie comfortably beside each other, but will show spontaneity.

The first chore was to decide which value and color of paper to use for this portrait. This is especially important with portrait painting, where tonal variations of flesh are often subtle. There is a danger with a dark or light paper—values can contrast too much. I chose a middle-value gray, Fabriano Stone Gray Ingres, to help me achieve the values of the face. I used this middle-value as a starting point.

I used slightly lighter or darker pastels, gradually building up to the main highlights and darkest parts. When I painted the dark parts, I dragged the pastel gently over the paper. I allowed the cool gray to show through the pastel and suggest cool tints within the dark areas. This process was useful in the shadows.

Sketch And First Stage—First, I sketched the face, relating points and lines to each other. The points at the base of the nose and the ends of the eyes formed a triangle. I sketched the top of the ear in relation to the eye level. The outer slope of the ear was parallel to the slope of the nose. The slope of the nostril was similar to the slope of the eyebrow. I made a separate sketch to show these relationships. I do not always strive for a likeness of the sitter. The likeness comes if I accurately judge the relative spacing, positioning and angularity of these points. Sometimes I slightly emphasize the angularity of a line to bring out a characteristic that interests me.

In drawing the portrait, I used combinations of blue-gray tint 4 and warm gray tint 3. I added tenta-

tive strokes of value, in green-gray tint 1 and bluegray tint 4 with side strokes of pastel. I did this to feel my way into the painting.

Second Stage—I first looked for the main structural planes of the face. I indicated these lightly with side strokes of green-gray tint 4. Details were ignored. I drew the eye socket with flat strokes of color, keeping it mostly in shade. This is because the underside of the eyebrow was turned away from the light and cast a shadow that extended below the eye. Within this shadow a little area of light caught the upper eyelid where it curved over the eyeball. The upper lid also cast a line of shadow on the top of the eyeball. The lower lid blended into the face. Many beginners make the mistake of drawing a line around the whole eye. The only line is under the upper eyelid. I extended the eyebrow as a continuous shape down the side of the nose, over the cheek and under the nose.

I used mostly green-gray and blue-gray. Then I indicated flesh tints with burnt sienna tints 0 and 2 on the forehead, nose and chin. I added a little background value with the blue-gray to help define the shape of the face. I began to paint the cap and jersey with indigo tints 4 and 6.

Third Stage—This was a fairly simple stage in which I began to strengthen colors and values already on the paper. I added more blue-gray to the shaded eye socket and the side of the nose, and a little green-gray under the nose. I was careful not to cover up or overwork the previously applied pastel. Leaving some of this pastel uncovered gave a look of freshness. I dragged a little Indian red tint 2 over the cheeks, forehead, nose and chin. I began to place highlights with burnt sienna tint 0. The eyes were slightly darkened with warm-gray pastel.

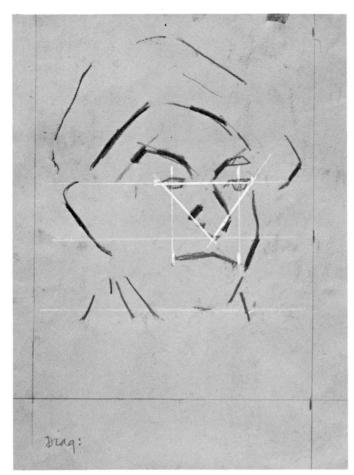

Sketch

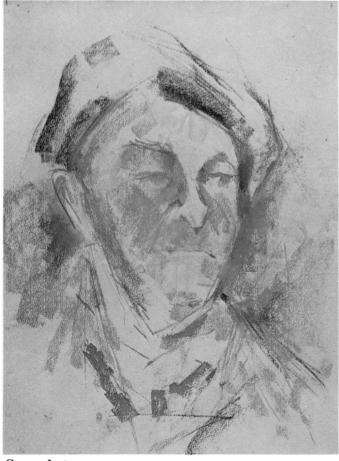

Second stage

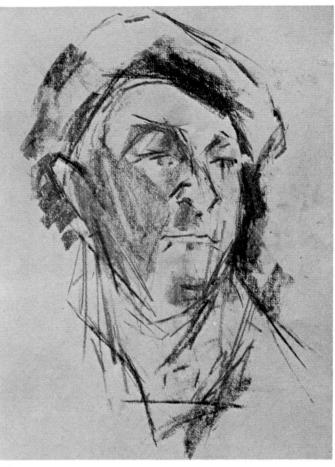

First stage

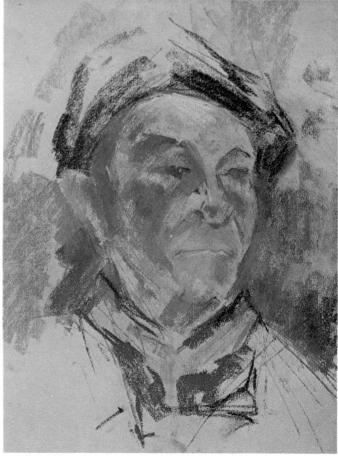

Third stage

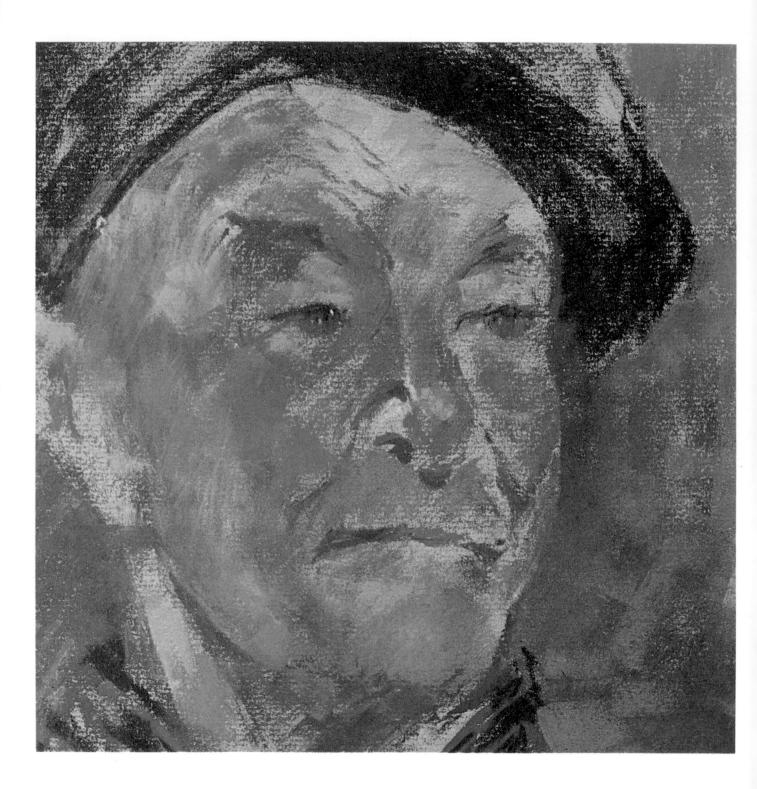

Final Stage—I painted the background with some of the colors I used in the face—warm gray, greengray and traces of burnt sienna. The cap was strengthened with indigo firmly pressed on the paper. I built up color on the face, repeating the previous colors with greater pressure. Some of the previous applications were left uncovered. I did not paint the white of the eye, but left the original gray. I added just a little more pressure to the dark shadow of the eyelid to create just a hint of highlight. Never use white to paint the white of an eye. Use a pale gray, such as cool gray tint 1. I used little color for the mouth. I just indicated the upper lip and used a hint of light pastel for the lower lip. The jersey was drawn with bold strokes of indigo and touches of black.

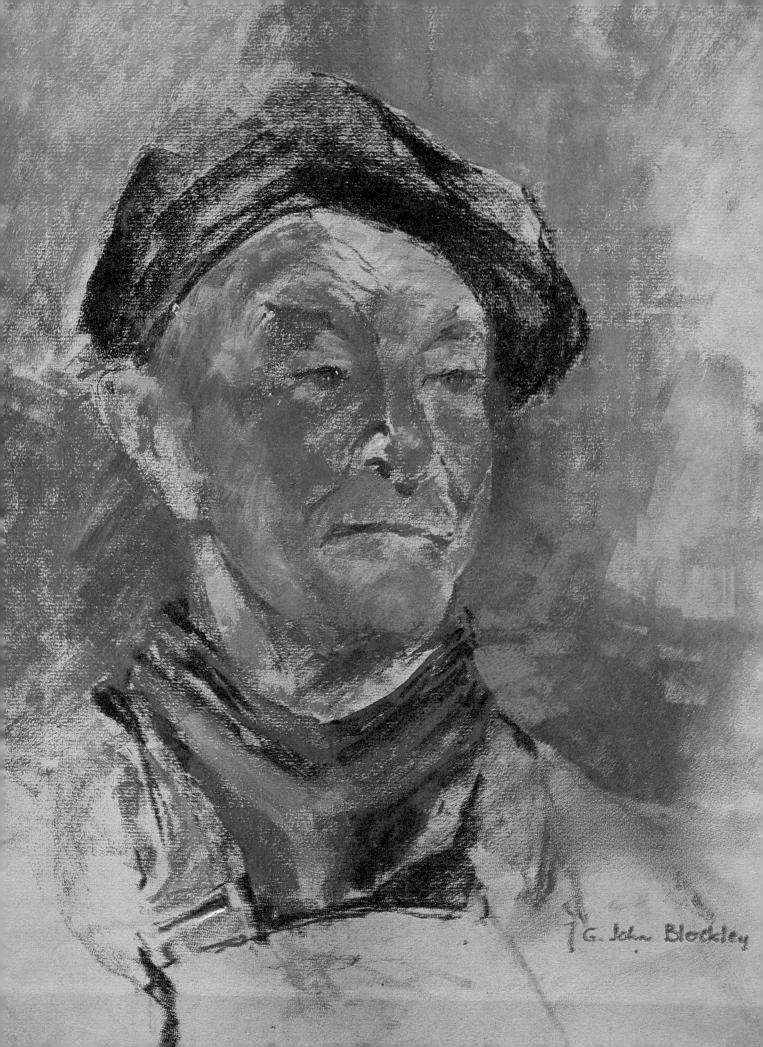

Northumberland House

This old house attracted me with its weathered, tiled roof that was partly covered with lichen and moss. Some of the original orange of the tiles showed through. Before I started to paint, I considered the perspective of the main building and its two projecting wings. Perspective drawing is not difficult. Just think of the building in two parts.

First, think about the perspective of the left wing of the building, as illustrated below. Look in the direction of the arrow. From this viewpoint, the roof and all the lines in the building taper away. This is especially noticeable in the roof. The end of the other wing slopes in the direction of the arrow. Its roof and sides also taper away.

First Stage—I used the perspective sketch to draw the building. Draw a building such as this with pencil first to make sure the drawing is proportioned correctly. Sketch the whole building lightly so you can easily make adjustments. It is irritating to draw parts too big and discover there is not enough room on the paper to complete the drawing. I prefer to draw with an ordinary pen nib. For this painting, I used brown drawing ink and Stone-Gray Fabriano

Ingres paper. I drew the outlines by slicing the pen quickly across the paper. I occasionally drew in another line or two, close together to avoid a tight, overly careful appearance. This drawing method helps get rid of the initial fear of empty paper. I always feel apprehension or expectancy when faced with a clean piece of paper. It is good to let some of the lines show through in the finished painting. I hope to create involvement in the painting by letting the viewer discover and question the initial exploratory drawing. Even the simple action of drawing a line has an emotional and personal side to it. Next. I used a paintbrush and brown ink to block in dark areas. This quickly gave a volume to the outline. It created areas of dark brown in addition to the gray of the paper on which to paint pastel. At this point, there was a pattern of values: dark on the end of the building, then a light area, then another dark section and so on. This is known as counterchange. I did not fully draw the windows because I wanted to concentrate on the shape and volume of the building and the arrangement of dark and light areas. I did not draw a line along the base of the house. I wanted it to blend with the ground and not look as if it had just been placed there.

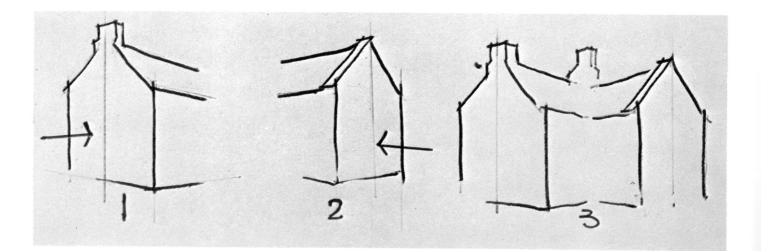

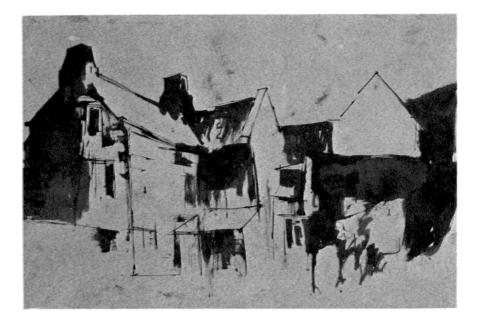

First stage

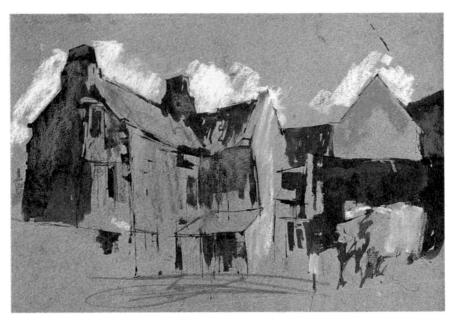

Second stage

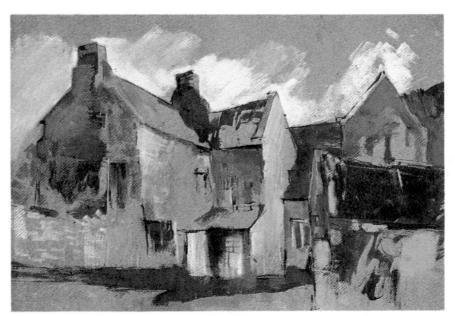

Third stage

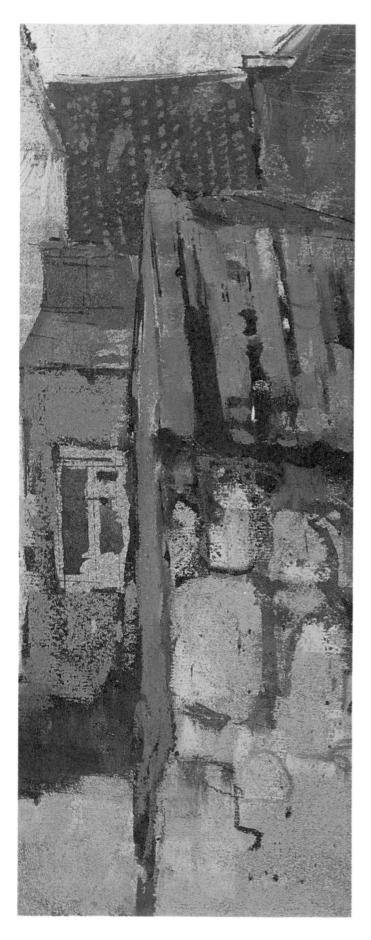

Second Stage-I added pastel to the drawing. I had to remember to apply the pastel lightly, without pressing too hard on the paper. I was still at the exploratory stage of deciding which colors to use. I also had to space out the pastel over the entire paper, not just in one place. I am more likely to achieve unity in a painting if I keep the painting progressing as a whole, rather than finishing one small part at a time. I used the side of pastel to make short, flat strokes of color on the painting. I placed a few strokes of silver-white around the chimneys and a little purple-gray tint 1 in the sky. I tried a few strokes of purple-gray tint 2 on the dark side and a tentative stroke of cadmium orange tint 6 on the roof. I could see this orange was too bright, and I made a note to subdue it with raw sienna later. This is the advantage of making the first strokes light and exploratory.

Third Stage-I strengthened colors by pressing pastel strokes over the first layer. In some places, I merely repeated the same color. In others, I overlaid the first color with another. I felt the white of the sky should be subdued, so I overlaid it with strokes of purple-gray tint 1 and cerulean tint 0. Hints of pink and pale blue-green began to appear in the sky. I extended the gray pastel over the inked parts of the building and added a little indication of tiles to the small foreground building. When I painted Hill Farmer, shown on page 37, I dragged light pastel over ink so the dark ink showed through and emphasized the light pastel overlay. In Northumberland House, the purpose of the ink was to darken the ends of the building. The ink helped create volume in the building. I did not use ink to emphasize the lighter, overlaid color as I did in Hill Farmer.

Final Stage—I expanded the various color patches to fill in the uncovered paper. I was careful to leave some paper uncovered because its gray color plays a part in the painting. I increased the amount of gray pastel on the chimney and at the top of the pointed wall at the right. These features are strongly silhouetted against the sky. I added definition to the window panes, the white door and the stones in the walls. The trees were quickly blocked in with tints of green-gray. I used the blue-gray of the walls to cool down the strong foreground shadow.

There are some important points to note in the finished painting.

Notice how I allowed the gray paper to show through the pastel in the light sky, the building and the ground. The paper combines with the pink and blue-gray pastels to give the painting an overall unity.

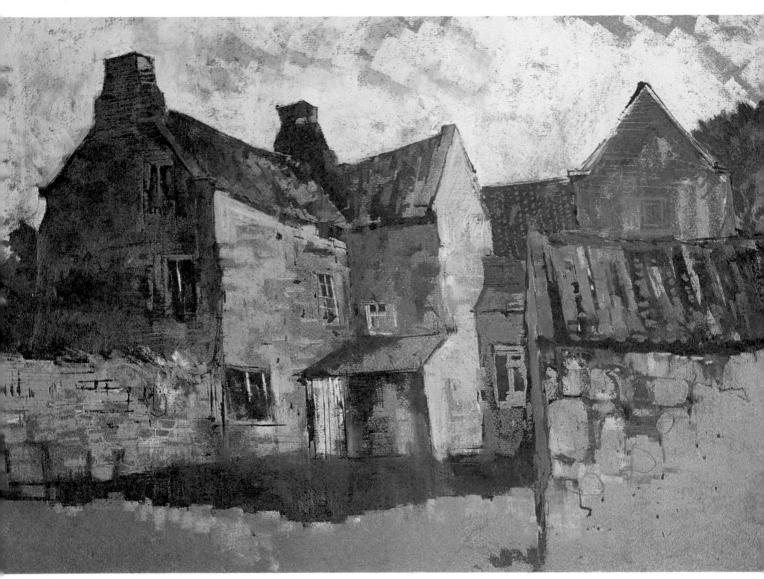

Final stage

Look at the painting and try to find the uncovered parts. They are not obvious at first glance. You may look hard and question whether some parts are paper or pastel strokes. This indicates successful use of the tinted paper.

The feeling of unity in the painting was also helped by using only a few pastel colors, mainly shades of gray and pink. The harmony would have been destroyed if I had scattered a lot of bright color around. I used one accent of bright color—a stroke of orange in the roof of the near building. I used a touch of this same color in the roof of the large building. You can see how some lines create parallel patterns with other lines. The chimneys have small, sloping parts that parallel the larger slopes of the roof. These are parallels that actually occur in the building. I created some additional parallels by making pastel strokes follow the slope of the roof. This is especially evident in the gray paper showing in the sky at top right. I applied the pastel in diagonal strokes.

You should always look for interesting characteristics of a subject and find ways to express them in pastel. Painting depends on careful observation and good technique.

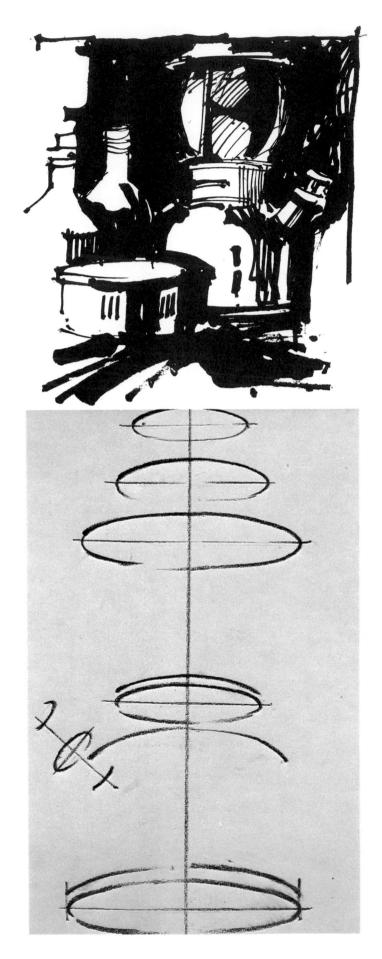

Oil Lamp

I rarely paint carefully arranged still-life groups such as pots or glass jars. I prefer to paint a group of objects just as they occur. I wait until my attention is caught by an appealing group of objects, preferably in some disorder.

When considering such a group, remember that all the objects do not have to be wholly contained within the picture. There are many excellent paintings in which objects are cut in half by the edge of the painting. An interesting pattern or color relationship is more important than a tidy image.

It helps to make a few simple sketches for such compositions. A brass oil lamp normally hangs in a corner of my studio. A quick pencil sketch I made long ago shows it standing on a bench surrounded by other bits and pieces. I viewed the group from different angles and made a number of little sketches, fitting the objects within a roughly drawn frame.

In this sketch, I sought a satisfactory arrangement of dark and light shapes of varying sizes, similar to those shown in the ink sketch at left above. I was primarily concerned with the way the lamp's shape related to other objects on the table.

I did not rearrange any of the objects, nor was I concerned with any single object. I was interested in the group as a whole. I looked at the shape of the objects and the spaces between them. *Negative shapes*, as these spaces are called, are often as interesting as the shapes of the objects.

It is a good idea to make little sketches with a soft pencil or piece of charcoal, concentrating on shapes and light and dark values. Walk around the group, look down on it, view it from below and don't move anything. See if you can discover a satisfactory composition within the existing group.

First Stage—For this painting, I concentrated on the lamp alone, hanging in its usual spot from a beam. The lamp required accurate drawing, especially because it was the only feature in the painting. The sketch at bottom left shows how I started to paint the lamp by drawing a vertical line through the center. Then I drew horizontal lines as baselines for the ellipses of the lamp. When I drew this basic construction, I had to judge how far apart the ellipses were. You can do this by visually estimating the relative distance between them. Or you can measure each distance with a pencil held vertically at arm's length. I had to compare the spacings of the ellipses with their widths. My problem was not only to draw the ellipses accurately, but also to judge the width and depth of each one and space them all relative to the height of the lamp. The entire image had to fit into the height of the paper. Judgment is present in all drawing, and comes from practice, so it is a good idea to make mental measurements often as practice, even when you are walking down a street. If you have time to stop and sketch proportions, so much the better.

Once I completed the basic drawing, I was ready to paint. I chose Tan Fabriano Ingres paper because it roughly corresponded to the dull brass color of the lamp. I was able to let some of the paper show in the painting. I drew the outline of the lamp with charcoal. For this demonstration, I drew a much stronger line than I normally do. Charcoal is easily removed by flicking it with a cloth. I did this before applying pastel. **Second Stage**—I studied the values and colors of the lamp. The brass contained subtle changes of color and only a few dark values. I decided to leave these for later to get on with the easily identified dark areas. The light came from the left, so the lamp cast a shadow on the timber frame. This shadow was a good area to start with. I used a piece of madder brown tint 8 about 1 inch long and drew a wide stroke of color down the paper. I followed the contour of the lamp. This one downward stroke defined the profile of the lamp and created shadow.

The bottom part of the lamp cast a big, rounded shadow. I used indigo tint 4 to extend the madder brown shadow into this interesting shape. I worked a little indigo into the shadow near the glass bowl. This change from brown to indigo introduced a bit of variety into the shadow. The brown and indigo are similar in value, so they blend well together. With the same tint of madder brown, I painted the other darks—under the top rim of the lamp, on the

First stage

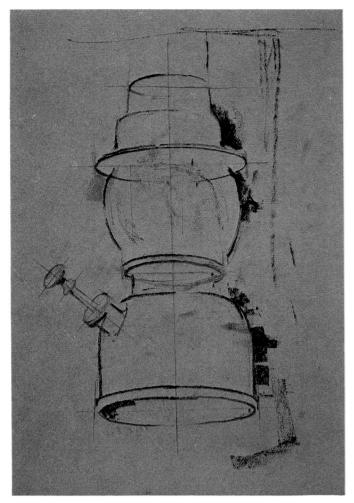

Second stage

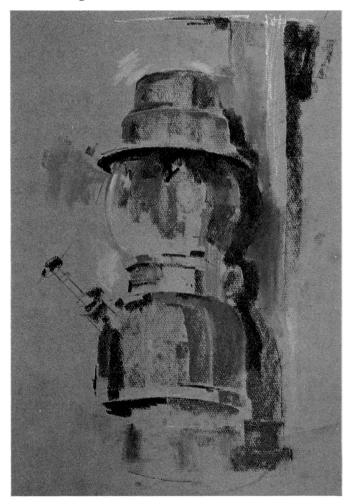

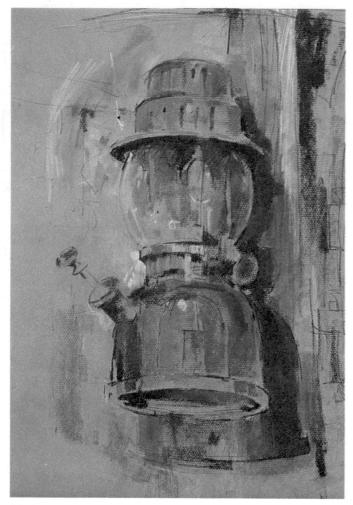

Third stage

base of the lamp and in the shadow behind the timber frame. These dark passages on the tan paper immediately gave volume to the outline drawing. At this point the painting consisted of the light charcoal outline and the dark shadows. Now it was time to paint the lamp itself.

I drew bands of Hooker's green tints 8 and 5 and a little warm gray tint 3 for the glass bowl. I used warm gray tint 4 and a little of the Hooker's green for the brass parts. I left quite a bit of the paper uncovered. There is always a temptation to put in highlights at this stage, but I like to leave these until the end.

Third Stage—The painting needed some finishing touches to pull it together. I strengthened the dark shadow at the bottom and the dark parts of the lamp. I intensified the lighter parts of the lamp by adding more of the original colors with increased pressure on the pastel.

Final Stage—I repeated the colors to cover more of the paper surrounding the lamp. I added a few accents of green and gray on the lamp and hinted at the white mantle inside. Finally, I firmly placed a few highlights.

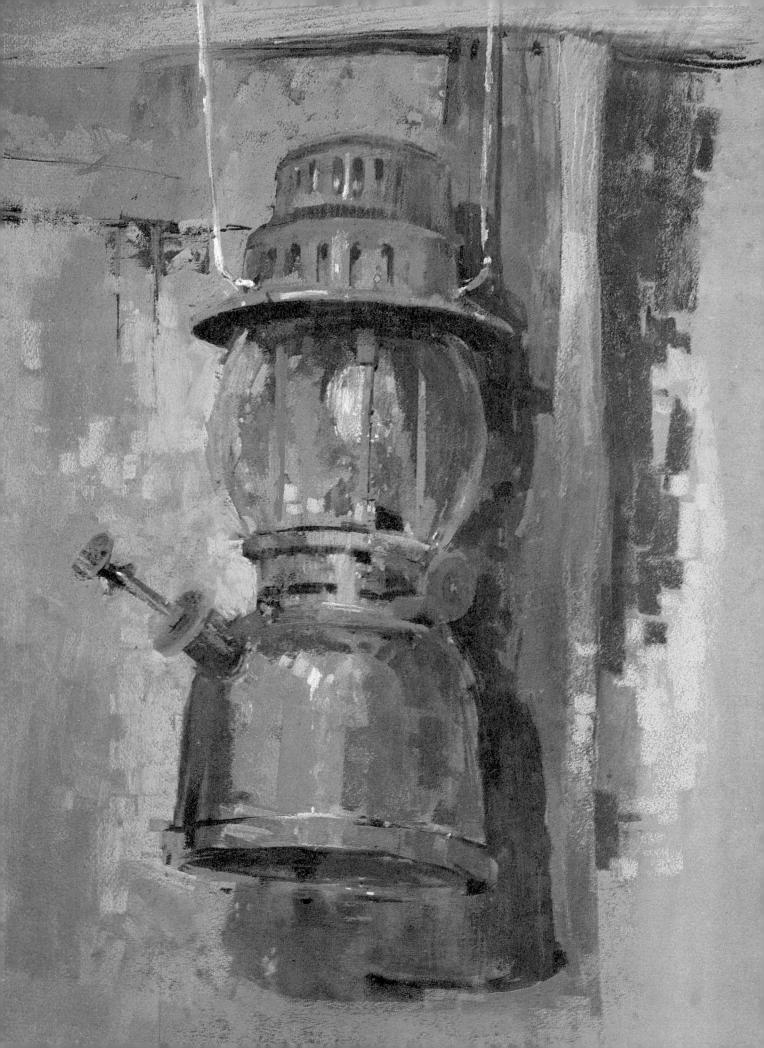

Apples

This quick pencil sketch explores the possibilities of a group of apples and a wine bottle. It is a deliberately rough drawing, made with a soft pencil. I used mostly the side of the lead instead of the point. By holding the pencil this way, I was able to block in the drawing with thick lines and quickly establish the pattern of light and dark.

This is a *working drawing*. Several such drawings can be made in a short time to decide the best composition. It is important to concentrate on patterns of objects. Do not become concerned with a "nice" drawing or with the pencil technique.

Pencil lines can be rubbed, smudged and worked over to create an arrangement that is pleasing. chose pencil for this drawing, but I sometimes use a square-ended oil painter's brush dipped in gouache or watercolor. I also use charcoal or pastel. Anything, that makes a mark will do for quick sketching. Some painters apply charcoal all over the paper, then rub away the light parts with an eraser. Rough exploratory drawings are fun. You should be uninhibited without fear of spoiling the work.

50-

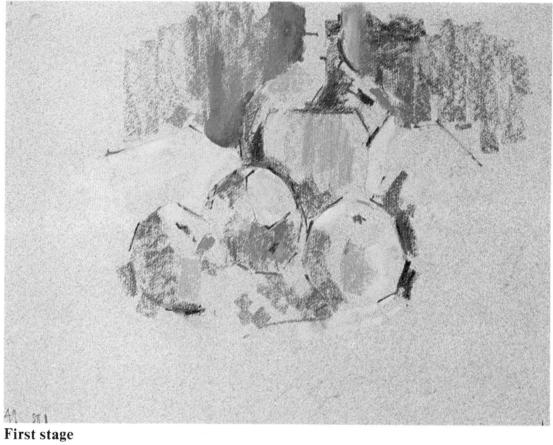

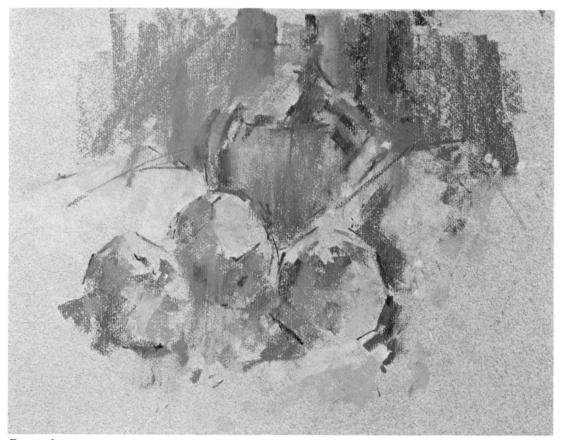

Second stage

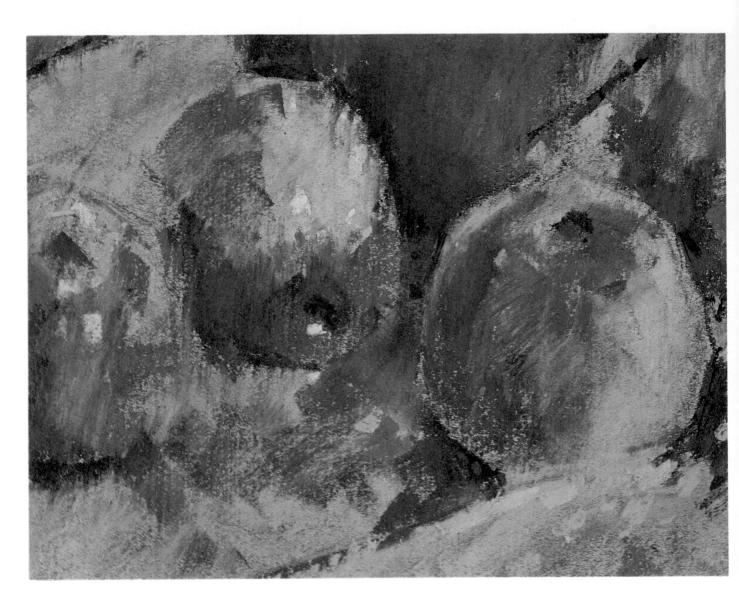

You can see in the later stages of the painting where I applied pastel with the same positive strokes. But I used the side of the pastel lightly, so I did not fill the grain of the paper. I wanted the paper to show through to give luminosity to the surface. I thought of the curved surface of the apples as being built up with a number of almost flat planes—like the facets of a cut diamond—so I made short, rectangular strokes of color.

The directions of pastel strokes are important they follow the general curve of the apple with short, angular changes of direction. This treatment relies on forceful pastel application.

I increasingly felt that I wanted to keep the painting light and sparkling. I wanted some space around the group of apples. I think this feeling came from the light reflecting off the apples. They are fresh, green and bright, with small flashes of highlights on their smooth surfaces.

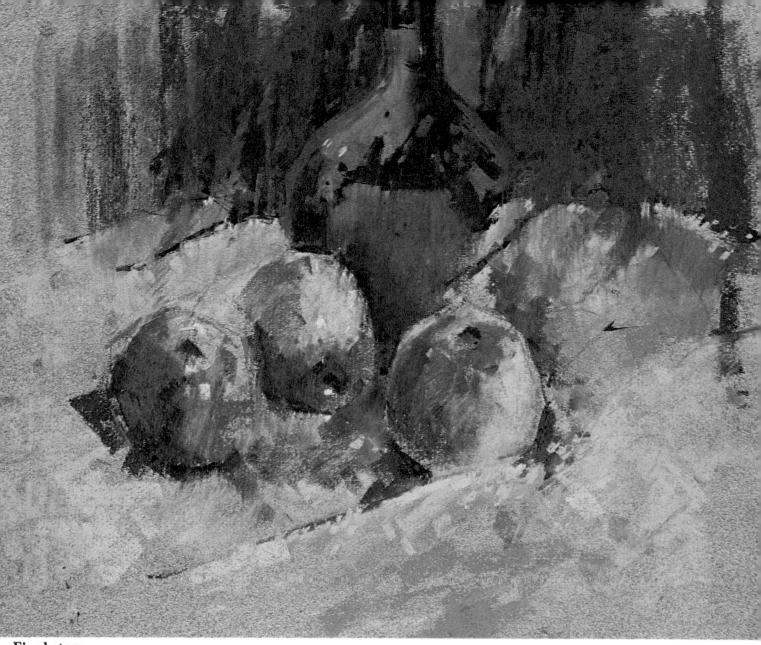

Final stage

I decided a horizontal picture would give a sense of space around the group. I chose a light paper, Tumba Ingres Purple-Gray, and left a lot of it showing in the final painting. The paper shows both in large, uncovered areas and breaking through lightly applied pastel.

First Stage—I positioned the apples and bottle approximately the same as in the sketch. I drew some guidelines for the apple shapes and the bottle with charcoal. I drew these lines with positive, firm strokes. I made the lines short, straight and angular rather than spherical because of my feelings for the subject. I felt the angularity of the drawing gave character to the apples and was in keeping with the direct strokes of the pastel. I started to make a few trial pastel strokes. I used green-gray tint 4 for the background, sap green tints 1 and 5 for the apples and indigo tints 1 and 3 for the cloth.

Second Stage—I continued to apply these colors, pressing them more firmly into the paper. I was careful to keep the pale sap green clean and unsmudged, because I wanted it to sparkle as reflected light. I sharpened the edges of the dark values on the bottle and added raw umber tint 1 and madder brown tint 6 to the label. I blended a few pastel strokes by gently rubbing them with my finger.

Final Stage—I continued to build up features, using the same colors. I intensified shadows under the apples and the bright highlights. I then added a few important finishing touches. I suggested a feeling of dazzling light reflecting from the apples by applying bright strokes of pale, sap green in vertical strokes. These strokes broke up the surface and the edges of the apples to create crisp flickers of light.

Roadside Trees

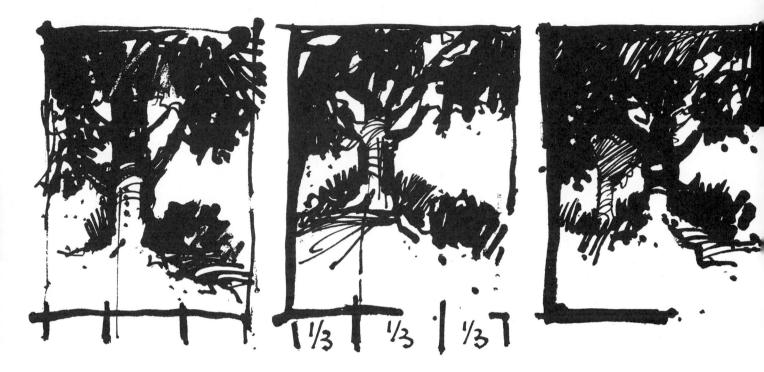

I was attracted by the large mass of a tree by the road. I made several thumbnail sketches of possible compositions, as illustrated above. These are quick sketches to help work out an interesting pattern of light and dark shapes.

I stopped thinking about it as a tree for a few moments, viewing it instead as a dark shape. I had to fit the shape on a rectangular piece of paper to create an interesting pattern. At this stage, I was not concerned with details of the tree bark and foilage. I wanted an agreeable composition.

My first reaction was to ignore the principle of not placing the main feature in the center of the picture. This guideline calls for placing the feature at the one-third position as indicated in the sketches above. I think any of these positions would be acceptable. They all have a pattern of light and dark shapes, agreeably varied in size.

Even so, I was determined to stick to my first reaction and place the tree in the middle. It is exciting to break the rules now and then. You can be rewarded with the more exciting or imaginative painting. I tried a little sketch with the tree in the middle. I realized that the distant tree on the left pulled the weight of the painting away from the center, so perhaps I didn't break the rule so much after all.

First Stage—I chose a dark paper, Fabriano Mid-Gray. With charcoal I drew the outline of the tree trunk and its branches. I drew the lower outline, where the large mass of foliage meets the sky, with crisp, rectangular shapes, not gentle curves. I considered the subject strong and positive, so I drew it with angular lines. I adjusted my drawing because I planned to apply the pastel with decisive strokes of color. The drawing, the method of applying the pastel and my concept of the subject were all related. It helps you to put a personal quality into your work if you can define your attitude toward the subject this way. Try drawing a tree shape with direct, angular lines. This helps you apply your pastel with conviction.

I was ready to apply the first pastel strokes. I squinted at the tree with my eyes almost closed to see the large mass of tree against the light sky. I

First stage

quickly painted the sky with strokes of cerulean tint 0, vermilion tint 0 and a few strokes of raw sienna tint 1. I left the color of the paper to represent the tree trunk. I added a few strokes of raw sienna and green-gray tint 1 to the foliage.

Second Stage—I added a little more pastel to the sky, repeating the colors already used. Then I added a few dark strokes of Vandyke brown tint 8 to the bushes behind the tree. I repeated the Vandyke brown in the branches of the tree and used gray-green for the lighter foliage and olive green tint 7 for the darker parts. I kept all the pastel strokes direct and unblended. My intention at this stage was to feel my way into the painting by working all over the paper. I wanted the painting to progress as a whole. Corrections are easier if the pastel is not overworked.

Third Stage—I pressed color into the paper, sliding the side of the pastel in random directions. Sometimes the strokes were placed side by side, and sometimes they overlapped. I painted the sky with firm strokes around the foliage shapes. The foliage edges firmed up as interesting shapes. Using the same greens as before, I continued to press the pastel into the paper to make strong darks. Occasionally, I blended the greens by rubbing them into each other with my finger.

I added additional touches of raw sienna to the trunk and branches. Next, I introduced a little

Second stage

purple-gray tint 2 into the tree, foreground and bushes. I thought the drawing could be emphasized, so I used the end of Vandyke brown tint 8 in the trunk and the branches.

Final Stage—So far, I had hardly touched the foreground. Should I paint it the green that I actually saw, or should I make an adjustment to suit the painting?

I decided the painting already contained enough green. I could have used cool greens, or even a pale mauve to reflect the sky. I could repeat a color already in the painting. The light part of the trunk was raw sienna, so I decided to use this color for the foreground. I added a few strokes of cool gray and green so the color was not too different from the subject.

Inexperienced painters should be careful when altering a subject. Such changes can lead to inconsistencies. I have seen paintings with shadows falling in different directions because the artist "borrowed" a feature from another part of the landscape. I have seen a tree moved to another part of the painting and its shadow left in the original position. It is better to think in terms of subduing a feature rather than placing it elsewhere. In this painting I merely altered the green foreground with raw sienna.

In making the change, I chose a color I had already used in the painting. Adding new colors would have made the painting busy and overworked.

Third stage

I chose a small area of existing color—a minority color in the painting—and repeated it in the foreground. The raw sienna in the tree trunk then became an accent, or echo, of the larger foreground. Echoes of color are useful—the viewer's eye travels over the painting and picks up these small repeats of color, pauses to look at them, then travels on again. The pause is momentary but enough to involve the viewer.

The tree trunk on the left was still the color of the paper. I continued the Vandyke brown of the bushes into the trunk to make it darker and give it a hard edge, contrasting with the light sky. This hard edge provided another detail on which the eye could rest. I was careful not to overdo it. I softened the upper part of the trunk by lightly dragging the color at the edges.

This process of changing from a hard to a soft edge is often referred to as *losing and finding* the edges. I also used this process in the foliage, where I silhouetted some edges crisply against the sky and then softened them again.

The branch in the upper right corner was painted as a precise detail to catch and hold the eye. It is a thick, solid, black line that emerges from the mass of foliage. It is silhouetted sharply against the sky before losing itself again in the foliage. Such small areas of intense contrast momentarily hold the attention of the viewer. I like to design them into my paintings.

All that remained to do was to strengthen the painting by adding pastel with increased pressure to various parts.

I was attracted in the beginning by the large mass of the tree. I was able to paint this effect by using a strong value range, with dark tints in the foliage contrasting with a pale sky. I emphasized the dark values of the tree by making the foliage larger than the light sky. The contrast of dark and light was emphasized by allowing small, intense bits of sky to show through the foliage.

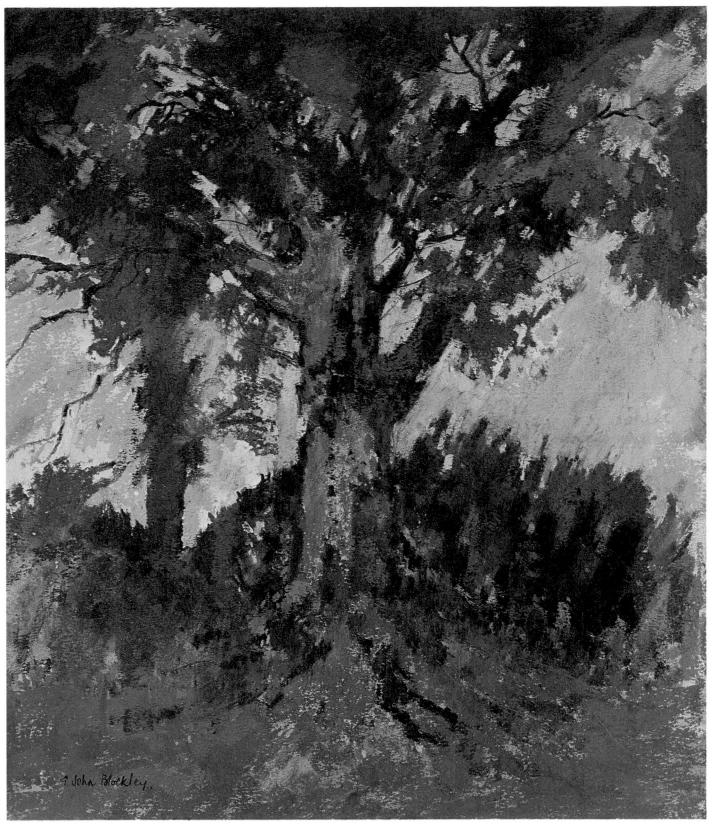

Final stage

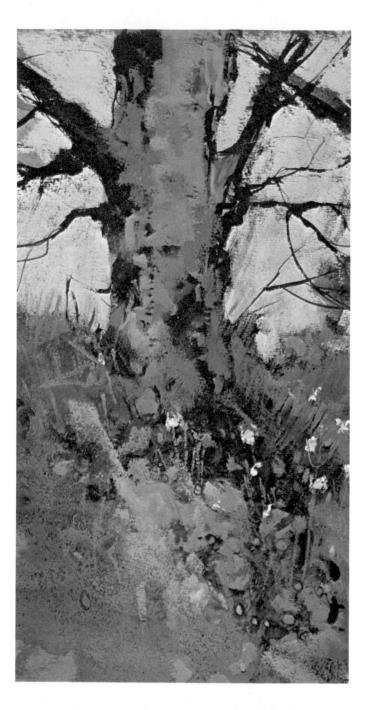

Trees

Trees are fascinating subjects for painting. The three trees in the finished painting at right were part of a row along the top of a grassy bank. I liked the pattern they made with the sky showing between them. I was intrigued by the mottled surfaces everywhere. The tree trunks were blotched with black, gray and tints of bronze. The pattern seemed to continue into the bank, with grass growing between patches of eroded soil. The painting captures the decorative surfaces. I saw it as a mosaic of echoing shapes and colors.

This kind of observation plays a great part in my painting. You should consider similar ideas. Look for an interesting characteristic of a subject and influence your painting toward it. In this painting, the interest was obvious—even the sky spaces between the branches were roughly similar in shape to the patterns in the tree trunks and ground.

I sketched the outline of the trees with charcoal on gray Fabriano Ingres paper. I immediately crosshatched the sky, temporarily leaving the paper to represent the tree trunks and branches. For the sky I used cerulean tint 0, with hints of Indian red tint 0. The lines were hatched close together so the sky's color was almost unbroken. I wanted to confine texture to the trees and ground.

This left a piece of gray paper with the light shapes of the sky on it. I started to apply the middlevalues. With the side of warm gray tint 3, I drew bands of color in various directions over the foreground. This pastel was slightly warmer and a little darker than the gray paper. By dragging it lightly over the paper, I was able to gradually indicate a pattern over the foreground. I then added firmer strokes with darker tints of the same pastel.

Occasionally, I softened an edge with my finger and left round and oval shapes of the paper uncovered. I outlined a few of the rounded shapes with the end of a sepia pastel. I continued, adding tints of autumn brown pastel as I worked the pattern into the trees.

Finally, I pressed strokes of sepia tint 8 into the paper to create the dark passages. Don't be afraid to paint strong darks. They are important in this painting to emphasize the pattern. I used the end of the sepia pastel to draw finer branches.

I followed the same procedure to paint the singletree study shown at left. I enjoy picking out a single motif such as this and painting a small, intimate picture.

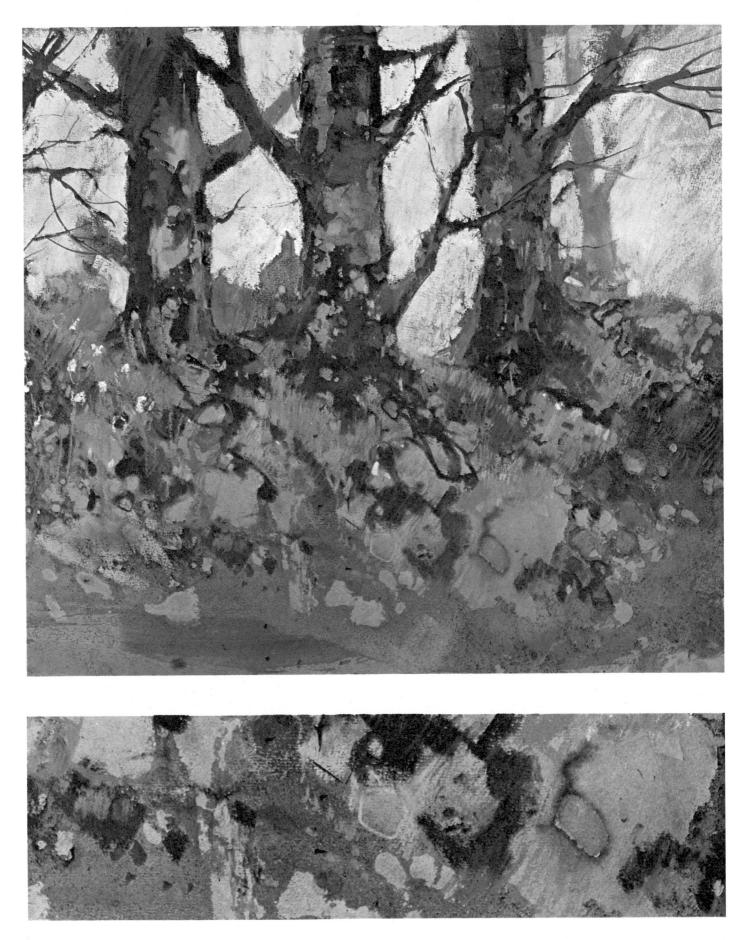

Cotswold Landscape

This landscape is typical of the countryside surrounding my studio—large and open, with wonderful skies. I love to go out, especially in the early morning or evening when the quality of light brings out the colors in the landscape.

In this painting I wanted to record the storm clouds building up. Even as I looked at the scene, rain slanted down to break the distant skyline. The sky was dark indigo at the top and lightened toward the skyline with a broken paler blue, almost green. It had a hint of pale cream here and there.

The lighter clouds seemed to glint with light against the somber indigo. I immediately felt the effect could be described best with short, quick strokes of pastel applied crisply and unrubbed.

The colors of the dark clouds echoed in the long sweeps of the distant hills. In other parts, the brown soil of the landscape was modified by the gray clouds to bands of dark purple-brown. These sweeps of color were relieved by hard-edged slices of a bright pink. When you have experience in looking at the landscape and painting it, you will think about pastel colors at all times, not only when you are painting.

First Stage—I chose Deep Stone Ingres Fabriano paper because it seemed to match the middle values of the landscape. I drew a few lines with charcoal to indicate the main shapes and contours of the landscape. These are the black lines in the top illustration.

I did not draw the precise shape of each field because that would create a danger of painting too many details. It would have created the tendency to fill each individual shape, as if I were painting by number. I wanted to apply pastel in sweeping motions to suggest the long undulations of the landscape. I drew only a few guidelines.

The profile of the tree was drawn with straight, angular lines. I pressed the charcoal onto the paper much harder than I normally do. I only needed the faintest guideline. Later, I had to soften the line drawing by flicking it with a rag before going on to the next stage. I did not want the black outline to show in the final painting. I lightly indicated the outline of the clouds with white pastel to establish their pattern. Clouds constantly change, but it is impossible to keep changing the painting. That's why it was necessary to find an interesting pattern and use it consistently in the painting.

The work so far consisted of lines drawn with the end of a piece of charcoal or pastel. Next, I used the side of the pastel to apply strokes of color on the paper. I drew the light values of the sky with silverwhite and a few middle-values with blue-gray tint 2. I indicated the lighter green of the tree with olive green tint 4 and the darker green with tint 7. The brief bands of light across the landscape were made with raw sienna tint 1. I was just beginning to feel my way into the painting, so I kept the strokes simple, and going mostly in the same direction. I was careful not to concentrate on any particular part of the painting. Instead I was intent on covering most of the paper with open pastel strokes. I filled in the spaces as the painting proceeded and built up the layers of pastel.

Second Stage—The pastel was applied with positive strokes but only light pressure. I continued to expand these strokes, using firmer pressure on the pastel to cover more paper. I constantly had to decide if the colors looked right. Gradually building up to the final intensity of a pastel painting is a good way to work. Mistakes can be removed with a brush, but I think it is good discipline not to rely on correction. I painted long strokes of purple-brown tints 1 and 6 and green-gray tint 1 across the foreground.

Third Stage—I stopped long enough for a good look at the painting. I even walked away from it for a few minutes. This kind of break is enough to allow you to look at the painting again with a fresh appraisal. Errors not previously noticed often become obvious. My interest was mainly with the sky, so it was important to stick to this in the painting. Were there any bright parts in the landscape that detracted from the sky? Yes! The pink to the right of the tree was too bright and had to be subdued. How could I do this? I could smudge it into the gray paper with my finger, but that would lead to an indecisive quality in the painting. I could have dusted it down with a stiff brush and applied new pastel of a slightly darker value.

I decided I could safely apply another quick layer of a darker value on top of the first light layer. When I did this, the colors in the landscape were sufficiently subdued in relation to the sky. Then I took a hard look at the sky. I decided the pattern of

First stage

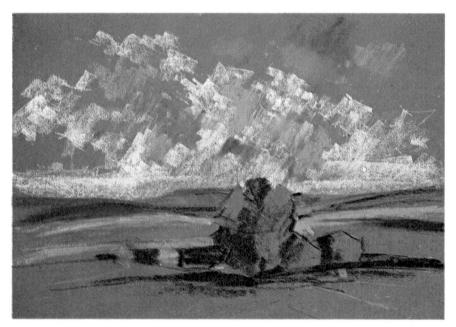

Second stage

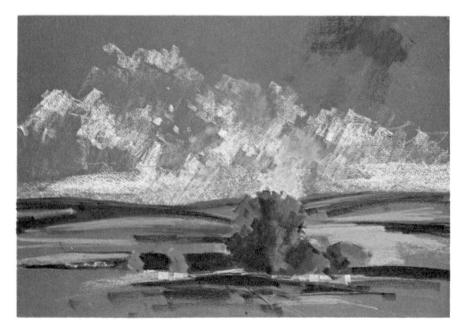

Third stage

the clouds was sufficiently interesting. Each light cloud almost echoed the shape of nearby clouds. All sloped in one direction.

Observe the pastel strokes in the clouds. The cloud shapes slope to the right, but the pastel strokes within them slope to the left. The direction of strokes helps create agitation in the sky, which draws attention to it. The strokes are short, quickly applied patches of color. I overlapped some of the pastel strokes so their edges blended, but did not rub them with my finger. This was an important stage of the painting where I looked critically at its progress. I built up the pastel with firmer strokes when I decided each part was satisfactory.

Final Stage—I completed the sky by adding indigo tint 3 along the top. I pressed in short strokes of cerulean tint 0 to create the greenish-blue pale lights in the white clouds. I strengthened the darks of the landscape with additional strokes of purple-brown and green-gray. I made some strokes crisp and hardedged and allowed others to blend together softly.

Throughout the painting, I kept my original interest in the sky. I painted the glints of light with crisp flicks of pale pastel and contrasted these with darker grays and blues. Sometimes the pastel was given atmospheric qualities by gently rubbing with my finger. I decided at the beginning this was the best treatment for the sky. I stuck to this decision and limited this treatment only to the sky. The landscape

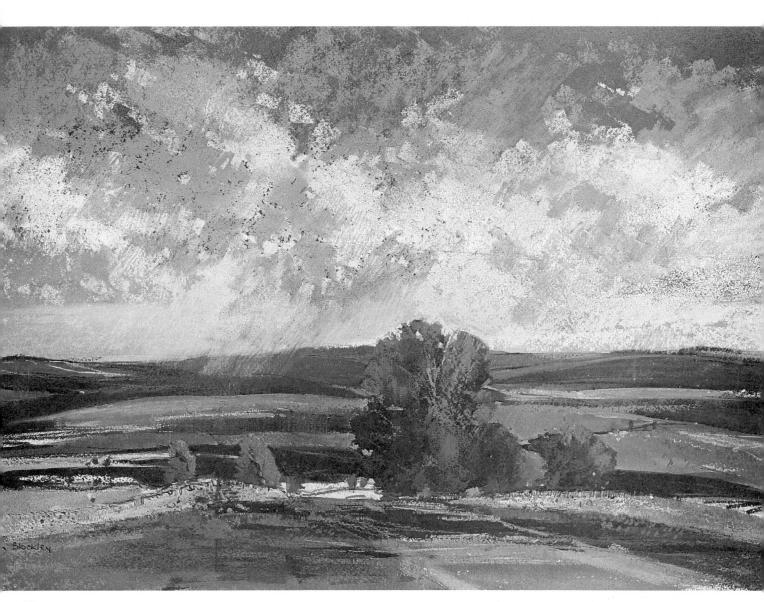

Final stage

was painted entirely with long strokes of pastel. The long strokes accentuated the short strokes in the sky. I allowed some light passages in the landscape, but mainly I kept the colors fairly subdued. The light was concentrated in the sky.

I also used smoother strokes in the ground by occasionally rubbing with slight finger pressure. In contrast, I left the sky unrubbed, in thick layers. The pastel granules clung to the paper surface and reflected light.

I wanted the sky to have layers of pastel. I encouraged this effect by *fixing* each pastel layer, spraying it with fixative. Then I applied new layers of pastel. I repeated this in various stages of the sky. I left only the final layer unfixed, which produced a shimmering quality to the light parts of the sky.

When painting, it helps to ask questions before each stroke. "Is this pastel color light enough, or dark enough? Is it the correct tint? Does it enhance the center of interest?"

Always decide what aspect of the subject interests you before starting to paint. Keep this aspect in mind by asking yourself questions while you are painting.

Fixing Pastels

There are two ways to fix pastels. You can use a diffuser: A tube is dipped into a bottle of fixative. Then you blow into the mouthpiece end and the fixative is sprayed on the painting.

The other method, which I prefer, is to spray from an aerosol can of fixative, as shown at right.

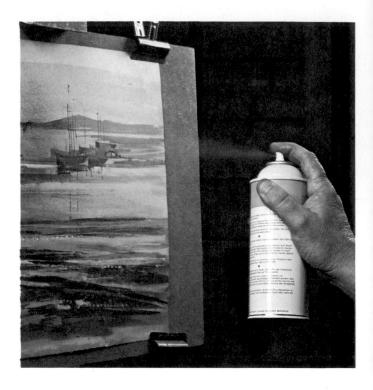

Index

A

Abstraction, 30 Acrylic washes, 34 Aerosol fixative, 8, 64 Apples, 50

B

Binder, 7 Boats, 34, 35 Brushes, 8, 11

С

Canvas, 12 Chalk drawings, 6 Charcoal, 8, 11 Charcoal, how to remove, 47 Color bands, 16, 18 Composition, 46, 54 Contrast, 56 Cottages, 24, 28, 30 Counterchange, 42 Cross-hatching 16, 28

D

Degas, Edgar, 6 Details, 26, 28 Diffuser, 64 Drawing ink, 8

E Easels, 10 Eraser, 8, 11 Equipment, 8

F

Farmers, 36 Feather duster, 11 Figures, 22 Fixative, 10, 63, 64 Flat planes, 52 Flesh tints, 38

Н

Hardboard, 12 House, 42, 44, 45

I Impressionistic treatment, 28 Ink, 11, 36, 42

L Landscape, 58, 62 Losing and finding edges, 56 Luminosity, 52

M Mat, 6 Muslin-covered board, 12

Negative shapes, 46

0

Oil lamps, 46 Oil paints, 7 Opaque color, 14 Overlapping dots, 16

P

Painting, 22 Paper, 8, 12, 13, 14, 15, 32 Parallels, 45 Pastels, 6, 7, 8 Pen nib, 42 Pencil, 8, 11, 20, 50 People, 22 Perspective drawing, 42 Photographic accuracy, 38 Pigments, 7 Portraits, 38

R

Refraction of light, 6 Rubbed pastels, 16, 18

S

Sandpaper, 12 Sketches, 13, 20, 22, 42, 46, 54 Spray diffuser, 8 Still life, 46 Storing pastels, 10 Strokes, 16, 52, 62 Suggested detail, 28 Т

Texture, 26 Thumbnail sketches, 54 Tints, 7 Tonal contrasts, 30 Trees, 54, 58

U Und

Underpainting, 32, 35 Unrubbed pastels, 18

V Values, 13, 38, 46, 47, 56 Volume, 48

W

Water, 34, 35 Watercolor papers, 32 Watercolors, 7, 32 Wood stick, 36 Working drawing, 50